IMAGES
of America
WORCESTER
1880–1920

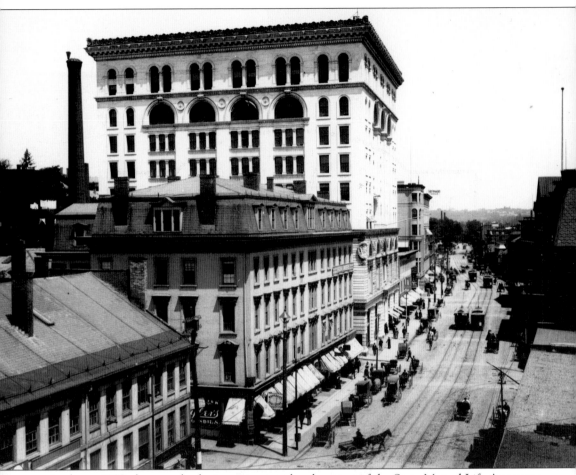

In this c. 1900 photograph, the imposing new headquarters of the State Mutual Life Assurance Company (chartered on March 16, 1844) looms over Main Street a few years after completion of the building. Owing to new construction methods, it was the first building in Worcester erected to the maximum height allowed by law and, for several years, was the city's only skyscraper. The building was designed by Peabody and Stearns of Boston and was constructed of white marble over a steel frame by the Worcester-based Norcross Brothers firm.

IMAGES
of America
WORCESTER
1880–1920

William O. Hultgren,
Eric J. Salomonsson, and Frank J. Morrill

ARCADIA

First printed in 2003.

Published by Arcadia Publishing,
an imprint of Tempus Publishing Inc.
2A Cumberland Street
Charleston, SC 29401

Printed in Great Britain.

Library of Congress Catalog Card Number: 2003103776

For all general information, contact Arcadia Publishing:
Telephone 843-853-2070
Fax 843-853-0044
E-mail sales@arcadiapublishing.com

For customer service and orders:
Toll-free 1-888-313-2665

Visit us on the Internet at www.arcadiapublishing.com.

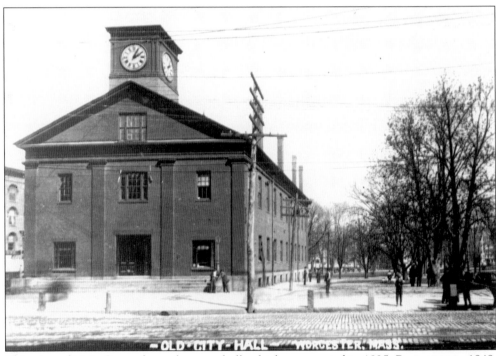

This view of Main Street shows the town hall, which was erected in 1825. Beginning in 1848, when Worcester became a city, this hall was used for municipal purposes until it was replaced by the present city hall in 1898. The town hall had many famous visitors, but none more so than Abraham Lincoln, who visited in 1848. The building seen to the left is on Front Street.

CONTENTS

ACKNOWLEDGMENTS

The photographs in this book are primarily from the collection of Frank Morrill and from a collection of photographer William Bullard's pictures, which are now owned by Dennis LeBeau. The authors would like to thank the following people for the use of their photographs to accent areas of the book: William and Carole Fox, Florence Rideout, Quentin Kuehl, Judith Giggey, and the family of Fred Fedeli.

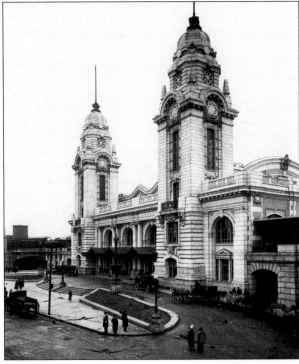

The new Union Station, which opened in 1911, is seen with its original towers in this 1913 photograph of Washington Square. Later, in 1926, the 175-foot towers were found to be unstable and were taken down. The recent restoration of the station included the replacement of the towers.

INTRODUCTION

The four decades from 1880 to 1920 were Worcester's golden years, a time when the rural country town became a thriving city. Worcester's diverse industrial base helped it weather the Panic of 1873, and by the 1880s, a housing boom began to fill the city's eastern hills with its landmark three-decker homes. The prosperity of the city's wire and ceramic shops attracted thousands of immigrant workers. Their demand for housing fueled the market for these three-family houses erected on lots that provided ample living spaces in the six- and seven-room apartments on each floor.

Worcester, known as "the Heart of the Commonwealth," exploded from a population of 58,291 in 1880 to 179,754 in 1920. Churches and fraternal organizations were founded at a rapid pace to serve this expanding, diverse population. It was reported that by the period's end, Worcester had 114 places of worship.

Schools were built at an equally rapid pace. Higher education never lagged behind in these prosperous years. Clark University was opened in 1889, and the Free Institute of Industrial Science became Worcester Polytechnic Institute in 1887. Trade schools were established to provide training for the mechanics who moved on to the city's manufacturing concerns.

The business area of Main Street was changed from a countrylike setting into a street lined with multistory brick-and-stone commercial blocks. The Board of Trade (today's Business Bureau), established in 1873, provided encouragement and cooperation among the businesses.

Diverse industrial expansion was the engine that drove this rapid growth. The steel-wire industry was a major employer, notably the Washburn and Moen Company, which employed thousands of workers in two huge complexes. The Norton Company, located in the Greendale section of the city, became the world's greatest producer of abrasives. Many other manufacturers produced a myriad of products, allowing Worcester to be known as the largest inland manufacturing city in the United States. In 1893, the *Columbian Tribune* reported that 144 industries and 978 establishments were in the city, employing 21,478 workers.

Prosperity brought with it benefits that appealed to the various economic classes. The Worcester Art Museum and the Oratorical Society were founded in the 1890s, and Bigelow's Garden provided roller-skating and other amusement. The White City Amusement Park became a popular entertainment center for the Worcester population.

Health standards increased with the establishment of Hahnemann Hospital and City Hospital. St. Vincent's Hospital served the Roman Catholic residents, and Fairlawn Hospital was long known as "the Swedish Hospital."

World War I brought a temporary halt to the expansion. Immigration was curtailed, and the economy went into a recession soon after the war. By 1920, business and housing starts rebounded but not at the former pace. Worcester's golden era was coming to a close.

Worcester is known as "the Heart of the Commonwealth."

One
1880–1889

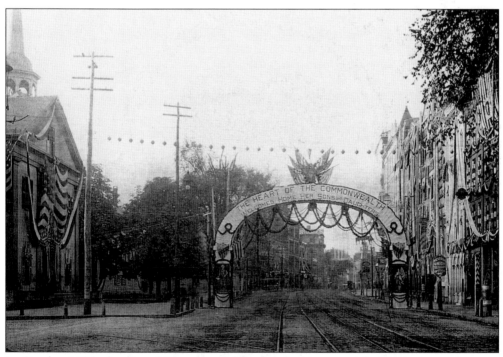

In October 1884, the city of Worcester celebrated the bicentennial of its incorporation as a town. The burgeoning city celebrated with a host of festivities, including the erection of this arch over Main Street at city hall. The old hall can be seen to the left, decorated with flags and bunting. The spire of the First Church, Congregational can be seen above the roof. The cobblestoned and electric-lighted street has a double set of tracks for the horse-drawn streetcars.

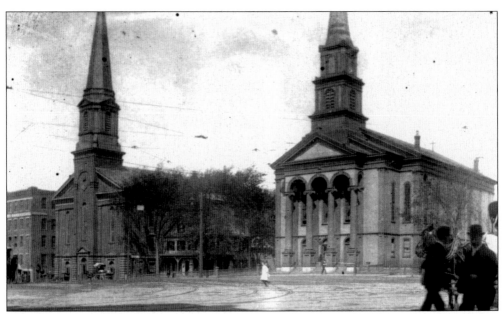

This view shows Salem Square over the years. The 1836 Baptist church, on the left, is shown after its remodeling in 1871. The Church of Notre Dame des Canadiens stands at the right. The building of the Worcester Center Galleria in 1969 necessitated the removal of this structure.

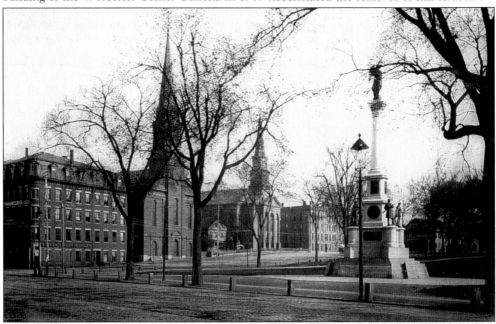

In this 1884 photograph, we see the remodeled Baptist church (purchased by the First Swedish Congregational Church in 1896) and Notre Dame Church beyond. An earlier 1813 Baptist church, destroyed by fire, occupied the same site. An earlier brick school was removed, and the Soldiers Monument was raised on the site. Dedicated in 1874, the monument stands 65 feet high. On the four sides are bronze plates with the names of the soldiers who fought in the Civil War. The square was the site of the town's hay scales and cordwood vendors. Wagons and, later, trucks sold country produce here until the present mall was built in the late 1960s.

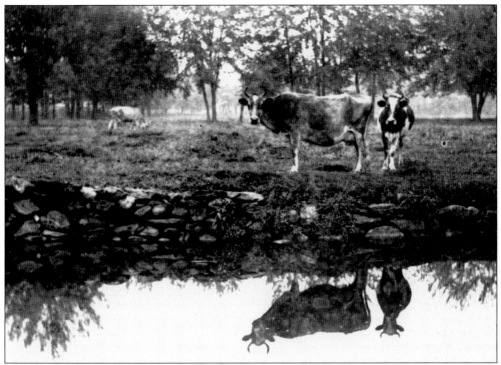

Taken in the mid-1880s at a "stone-walled" farm water hole in Tatnuck, this photograph shows the rural character of parts of Worcester at that time. The cow's reflection in the water gives the image an artistic look.

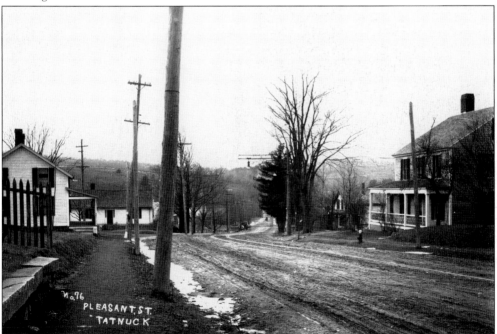

The farmhouses of Tatnuck residents sit close to Pleasant Street, in this c. 1888 view looking west toward Paxton. To the left of the center is the intersection of Mill and Pleasant Streets.

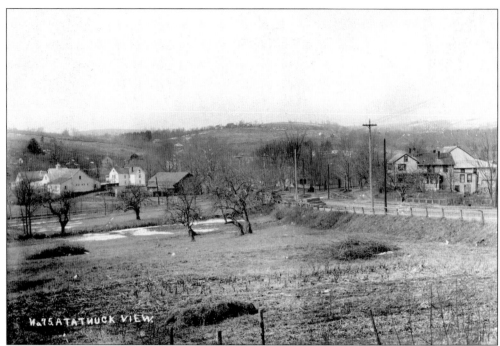

Many areas in Worcester retained their rural character even as the city developed into an industrial center. In Tatnuck, the sounds of industry were replaced with the quiet charm of a country setting. Pleasant, Chandler, and Mower Streets intersect in the center of this c. 1888 Tatnuck scene. The apple orchards, planting fields, and farmhouses add to the pastoral atmosphere of the setting. In the background loom the hills of west Tatnuck.

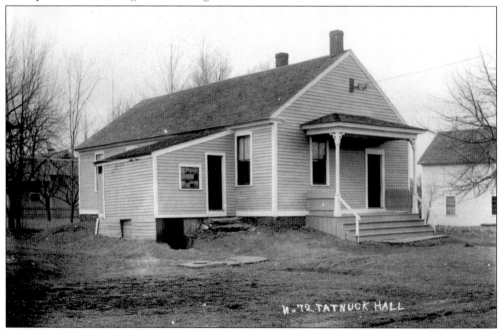

The Tatnuck community remained rural into the 20th century. The village hall provided a place for the social life of the area. This photograph shows the hall after a renovation in 1888.

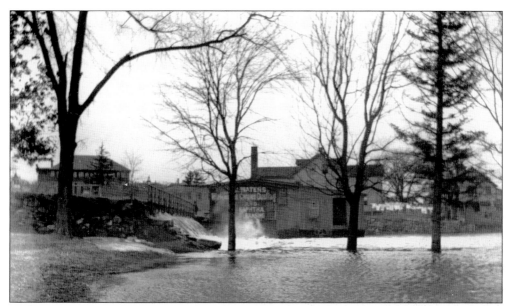

In the spring, snowmelt often raised the level of the streams, flooding the lowlands, as seen in this photograph of the Curtis Pond dam in Webster Square (then known as New Worcester). This stream provided waterpower to a series of mills and shops, including the James C. Waters and Son Carpet Dusting works (established in 1884), at 13 Curtis Street. Over the years this stream has caused major damage to the homes and businesses in Webster Square. The worst flood was in 1955, when several feet of water covered the area.

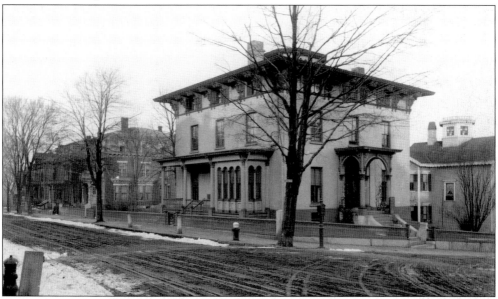

The Worcester Natural History Society occupied this building at the corner of Harvard and State Streets. The house was built c. 1873 by attorney Edwin Conant. The wide overhang of the low-pitched roof with a cupola marks this building as being in the Italianate, or General Grant, style. Before being torn down, the building was long the home of the Worcester County Extension Service and the Worcester Natural History Society, which evolved into the Worcester Science Center. Today, it is known as the Ecotarium.

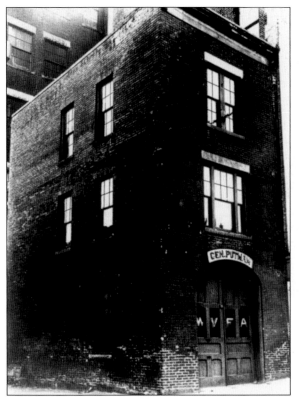

The Worcester Fire Department was founded on February 26, 1835. Worcester's first firehouse was built that same year at 21 Exchange Street and remained active until 1885. The *General Putman* referred to in the picture was a hand fire tub that was stored in the building. Box 4 Associates used it as a headquarters beginning on August 9, 1957. Founded in 1921 after the disastrous Knowles fire, Box 4 Associates was a group of businessmen dedicated to assisting the fire department in fighting fires.

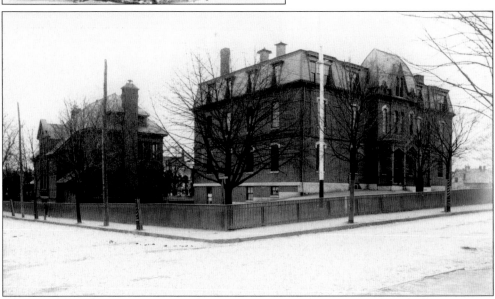

The original Woodland Street schoolhouses are shown at the intersection of Woodland and Claremont Streets in this early view. School No. 1 (right) was opened in 1870, followed by School No. 2 (left) 11 years later. On January 9, 1961, School No. 1 was destroyed by a fast-moving fire. In the aftermath, both schools were demolished and replaced. That replacement school was itself demolished to make way for the ALL (Accelerated Learning Lab) School, which opened on this site in 1999.

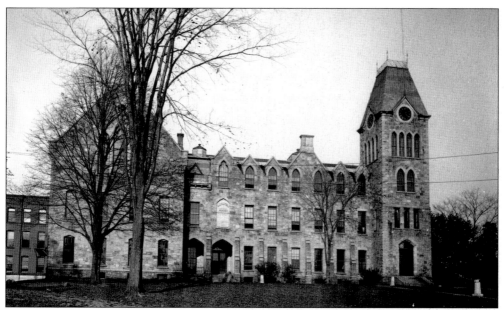

Pictured is Boynton Hall, at Worcester Polytechnic Institute. To establish this institute, Templeton native John Boynton in 1865 gave a portion of his fortune, to which was added a sizeable gift from Ichabod Washburn. Stephen Salisbury donated the land for the institute, and Stephen Earle designed the Gothic-style Boynton Hall in 1868. The institute's philosophy was to instruct students by establishing a policy of merging theory with practice, an approach that continues to this day.

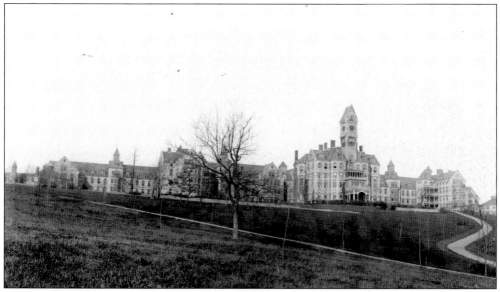

The extensive layout of the Worcester State Hospital is shown in this photograph from 1884. Opened a decade earlier, the sprawling complex of the "Worcester Lunatic Asylum" was enlarged several times before the beginning of the 20th century. The Victorian Gothic clock tower remains a landmark. Unfortunately, a disastrous 1991 fire destroyed several of the vacant buildings and adjacent wings.

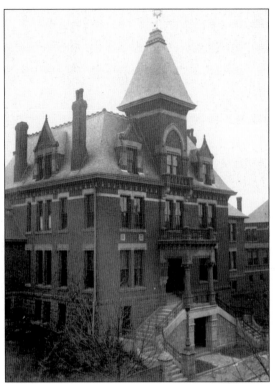

This photograph shows the administration building of City Hospital, on Prince Street. Founded in 1871, the hospital owed its growth to George Jaques, whose bequest included the land upon which the hospital relocated in 1874. Until the opening of the administration building in December 1881, the hospital was housed in the former Jaques estate. For Jaques's support, Prince Street was renamed Jaques Avenue by the city in 1889. Today, the former hospital buildings are used for a variety of services, including a clinic and addiction center.

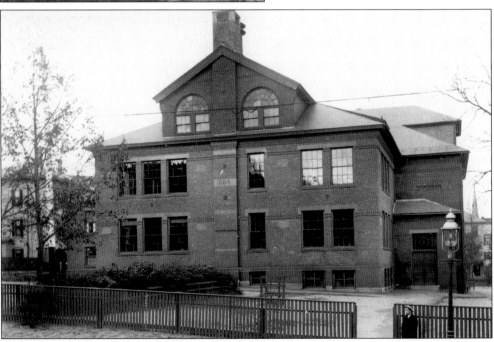

The original Chandler Street Schoolhouse, occupied in 1885, was designed by the firm of Barker and Nourse, architects of several city schools of this period. After 90 years in operation, the school was closed in June 1975. It was demolished early the following year to make way for its replacement, the Chandler Community Elementary School.

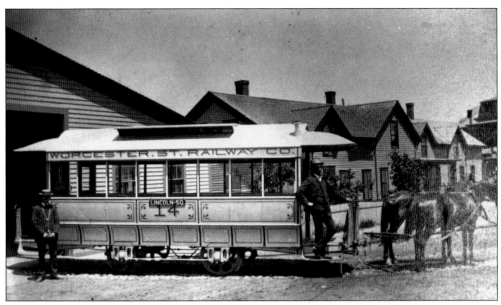

The driver poses nonchalantly on the platform of a horsecar of the Worcester Street Railway's closed car No. 14, in this 1880 photograph. The Worcester Horse Railroad began operation in 1863 and became the Worcester Street Railway in 1867.

The Lincoln Square Baptist congregation was organized in 1881. The following year, the congregation purchased a lot on Highland Street next to the Worcester County Courthouse, and plans were drawn for the construction of a church, which was dedicated in June 1884. Following years of controversy, the land and church building were taken by the state in 1956 for the expansion of the courthouse. The congregation then erected a new edifice on Burncoat Street, which was dedicated in March 1957. This photograph shows the original church on Highland Street, with Lincoln Square in the distance.

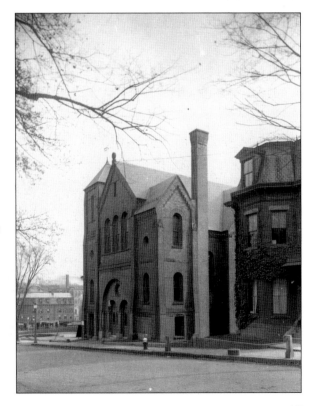

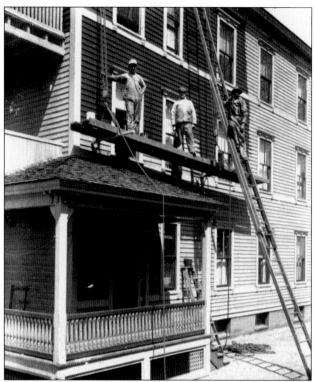

The painting of a three-decker usually signified its completion. In this view, workmen take time off to pose outside the second floor of one such tenement, which seems to be awaiting a final coat of paint. The proliferation of three-deckers gave rise to a network of businesses that catered to the various stages of their construction.

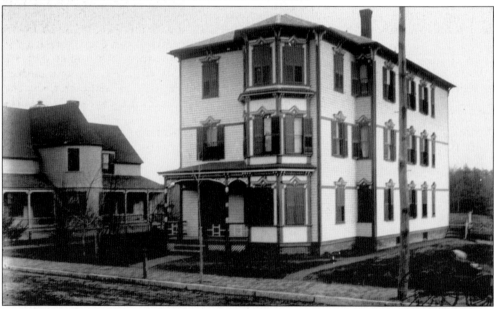

It is estimated that about 6,000 three-deckers were constructed in Worcester between the 1860s and the 1930s. Constructed primarily for the working class, the three-deckers were usually erected within walking distance of a factory or machine shop. Many became owner occupied, with several generations of a family living under one roof. Shown here is an atypical three-decker, constructed without second- and third-floor porches. Notice the decorative exterior features.

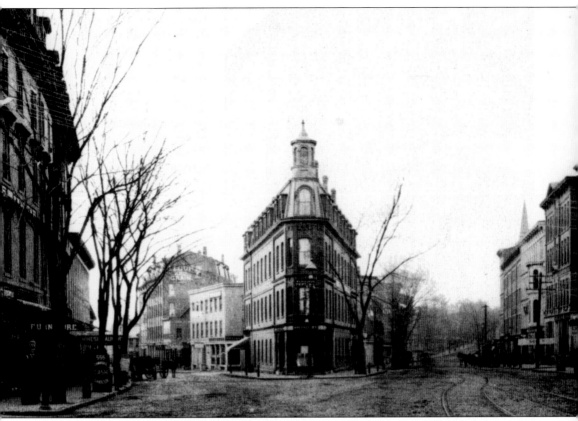

In this *c.* 1887 view, the flatiron building (commonly called the Scott Block) denotes the intersection of Main and Southbridge Streets. The Scott family, owners of the edifice, operated a drugstore on the first floor. Constructed in 1866, the building was one of the more modern structures erected in the fledgling post–Civil War city. After years of controversy, the city acquired the structure and promptly demolished it in 1928. The *Evening Gazette* of September 27, 1927, noted, "The flatiron building, for more than 40 years a blot to the beauty of Worcester, and for many years a hindrance to the quick and safe movement of traffic at Franklin square is to be removed." Today, the site houses a small park.

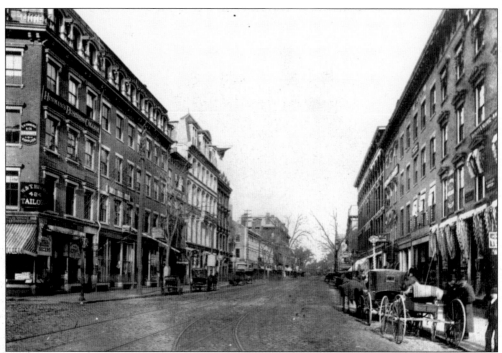

Main Street appears quiet in this view looking toward Lincoln Square c. 1887. By century's end this portion of Main Street would look quite different. Many of these buildings would be altered, some being enlarged with additional floors, as the demand for downtown business space remained high. The commanding State Mutual Life Assurance building, a symbol of the city's increasing business strength, would also appear on the Main Street landscape in the closing years of the 19th century.

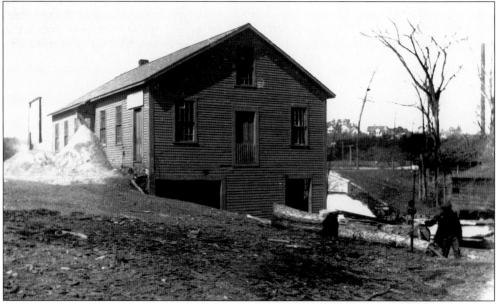

In this very early scene of a sawmill enterprise in Tatnuck, one of the workmen is preparing logs for sawing. Notice the large pile of sawdust at the bottom of the chute in front of the building.

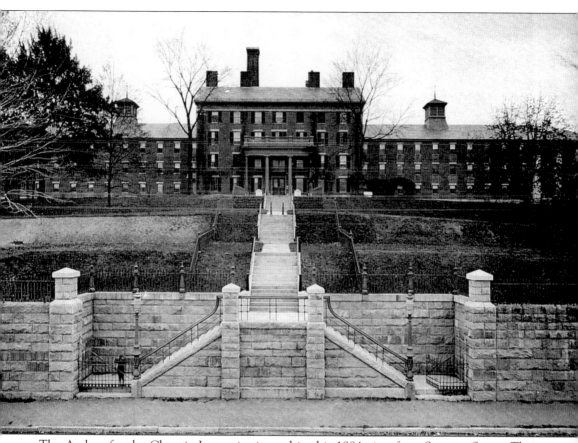

The Asylum for the Chronic Insane is pictured in this 1884 view from Summer Street. The asylum opened on October 23, 1877. According to the *Worcester City Directory* of 1888, "the inmates of the Asylum consist only of such chronic insane as may be transferred thereto from other Hospitals by the Board of State Charities." The construction of Interstate 290 in the late 1950s necessitated the asylum's removal.

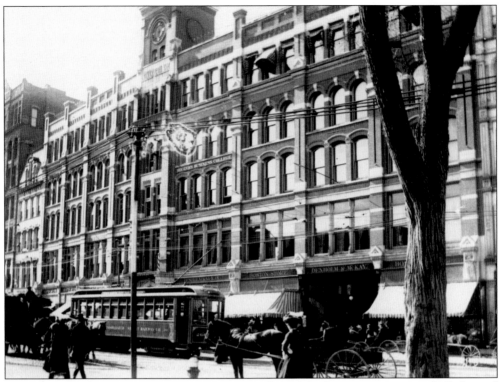

The Clark Block, an imposing structure at 484–500 Main Street opposite city hall, housed Denholm and McKay, the city's most prestigious department store. Opened in 1870 and also known as the Boston Store, the business was founded by William C. Denholm and William C. McKay. It grew from 18 employees to a peak of 800 and became the largest of its kind in central Massachusetts. The building remained a Worcester landmark until bankruptcy forced the business to close in 1973. The sign above the third-floor windows to the right of the building's center is for Becker's Business College. This early photograph illustrates the building's commanding facade.

This unusually quiet street scene shows the intersection of Pleasant and Main Streets in 1884. Notice the linear pattern of the cobblestone streets. The double set of tracks was used only by horse-drawn streetcars. The electrification of streetcars took place between 1891 and 1893.

Two

1890–1899

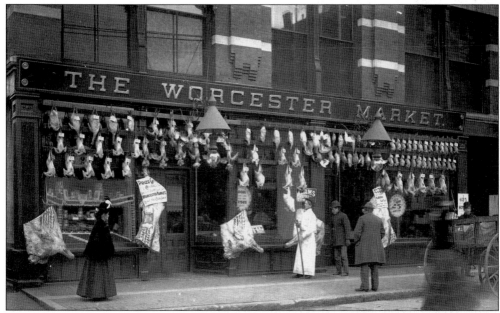

On a blustery winter's day in the 1890s, an employee of Worcester Market helps a customer select a fresh chicken from the store's outside rack. An advertisement lets passersby know that orders can be placed for prized Chicago World's Fair cattle that has been "dressed expressly" for the store. The market was located on Main Street in what later became the Royal Theater, after Worcester Market owner Fayette Amidon moved next door to his newly built market in 1914.

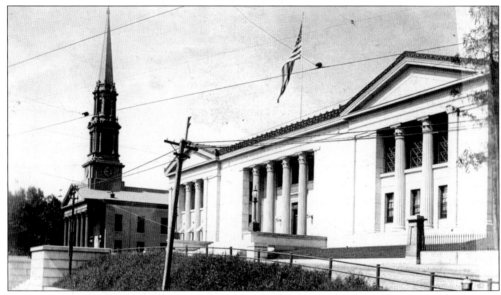

A unique view of Court Hill can be seen in this 1898 photograph. The Unitarian Church was founded as the Second Parish in Worcester by dissidents of the original First Church of 1713. A new church parish was organized in 1786, with Rev. W. Aaron Bancroft. A house of worship was built on Summer Street but, in 1849, it burned down. The church shown here was built in 1851, with a tower inspired by English architect Christopher Wren. The hurricane of 1938 blew the tower into the sanctuary, destroying the interior. Work began immediately to rebuild the sanctuary and tower to its original design. The Worcester County Courthouse dates from the incorporation of Worcester County in 1731. The courthouse, built in 1843–1845, underwent a major expansion in 1898–1899, creating the present-day facade.

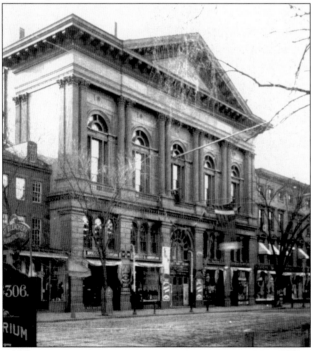

Mechanics Hall, one of Main Street's outstanding buildings, was designed by Elbridge Boyden for the Worcester Mechanics Association. Ground was broken for its construction in July 1855, and the cornerstone was set on September 3 of the same year. The building, which cost approximately $162,000, was formally dedicated on March 19, 1857. The superb acoustics in its 130-foot-long hall made it a popular venue for speakers, performers, and musical groups. Henry David Thoreau, Charles Dickens, Mark Twain, and several presidents spoke here. The classical structure began a steady decline in the 1930s but was rescued, restored, and reopened in November 1977.

The new city hall, designed by Peabody and Stearns, was built of Milford pink granite by the Norcross Brothers Company. The cornerstone was laid on September 12, 1896, with much fanfare, including a parade with Civil War veterans. The building was dedicated on April 28, 1898. Originally containing 60 rooms, it was finished in quartered oak throughout. Located on the site of the old town hall and the Old South Congregational Church, it has a stately Florentine tower that rises 140 feet, giving the building a total height of 205 feet. The clock in the tower weighs 820 pounds and has a bronze dial that is 14 feet, 6 inches in diameter. The building's massive 285-foot width gave it a presence that anchored the west end of the common, which was long the center of commerce and transportation.

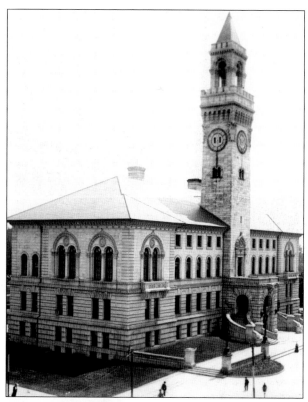

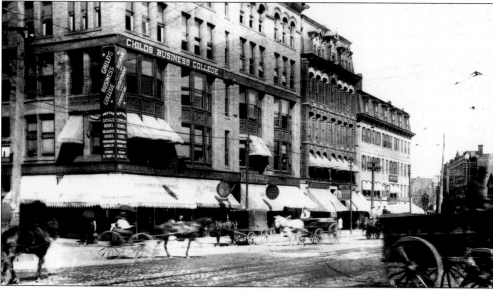

Traffic is brisk at the intersection of Front and Church Streets near Salem Square, in this late-1890s view. In the Front Street business block, Child's Business College was located above Rocheleau, Granger and Company, a local clothing concern. Next to the college was the Belisle Printing and Publishing Company, publishers of the French daily *L'Opinion Publique*, just one of a handful of ethnic newspapers published in the city. The entire block was demolished in the late 1960s to make way for the Worcester Center urban renewal project.

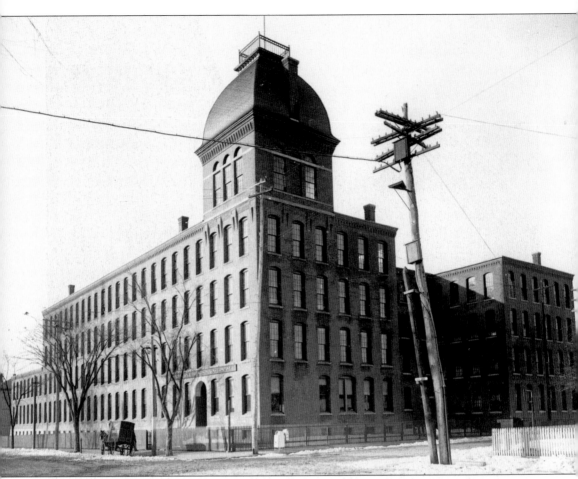

The commanding tower of the Harrington and Richardson Arms Company, the successor to Wesson and Harrington, dominated the Park Avenue skyline for decades. The company produced weapons such as flare guns in World War I, Reising submachine guns in World War II, and M-14 and M-16 rifles during the Vietnam War. Established in 1871, the company operated at 18 Manchester Street until 1876, when it moved to 31 Hermon Street until it built and occupied the 120,000-square-foot building at 320 Park Avenue in 1893. The company, which once employed some 2,000 workers, shut down operations in Worcester in 1974 and moved to Gardner. Despite protests from local preservationists, the building was torn down in the summer of 1985. A Walgreens pharmacy now occupies this site.

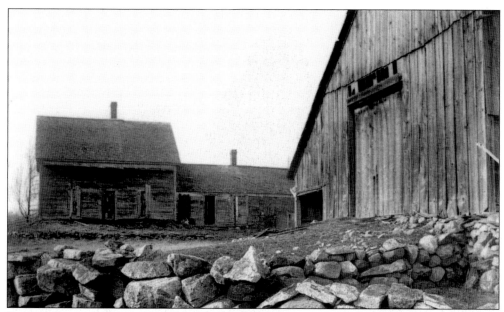

Despite the expanding industrial activity in Worcester, rural character was symbolized in the unpainted farmhouse and barns behind a rugged stone wall, typical of an early scene in Tatnuck.

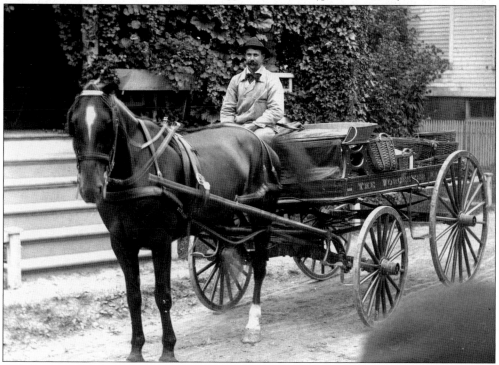

A delivery wagon from the Worcester Market, its bed full of baskets, is pictured here in front of a customer's house. Fayette Amidon established his grocery business on Main Street in 1894, and it quickly became popular with residents. In 1914, Amidon expanded his business and constructed a large store at the corners of Main and Madison Streets. The building soon became a landmark.

27

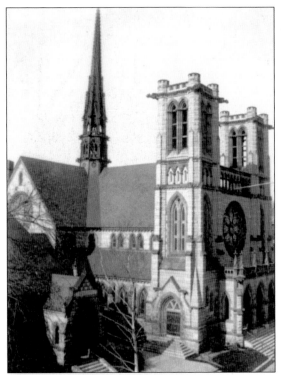

Chestnut Street Congregational Church today stands empty and unused at the head of Pearl Street. The church was designed by local architect Steven Earle and architect Clellan Fisher. It was constructed between 1895 and 1897, and this photograph was taken shortly thereafter. The 180-foot spire was removed in 1954 because of structural problems. The congregation was originally organized as the Union Congregational Church in 1835 by members of the First Congregational and the Second Congregational Churches and, later, the Salem Street Church. This, Worcester's best example of Gothic Revival architecture, was renamed Chestnut Street Congregational Church in 1936 with the merger of the Union, Piedmont, and Plymouth Congregational Churches. Worship ceased at Chestnut Street in 1982, after the members moved to Central Congregational Church.

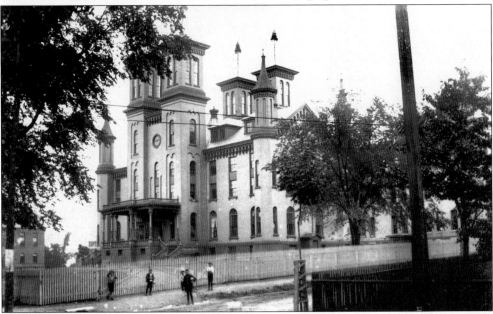

Davis Hall, designed by prominent Worcester architect Elbridge Boyden, was home to several establishments throughout its existence. It housed the Worcester Medical College, the Ladies Collegiate Institute, and the Dale General Hospital, which housed wounded Civil War veterans. In 1870, the building was turned into Worcester Academy. Sadly, this unique building was torn down in 1964. In this c. 1890 photograph, children play outside the academy grounds at the corner of Providence Street and Union Avenue.

Abel Swan Brown, the president of Denholm and McKay, established a lavish summer residence for himself on Wildwood Avenue. During the 1890s, Brown acquired more than 500 acres of land, eventually naming the estate Wildwood Park. His summer home, constructed entirely of native stone and lumber, was named the Hermitage. The estate included stables, a kennel, and its own gas plant. After Brown's sudden death in September 1899, the home reverted to his mother. After her passing, the estate was auctioned off in October 1904 and the main residence became known as the Hermitage Country Club. On July 4, 1942, the vacant structure burned in a fire set by vandals. In this photograph, the Hermitage appears to be nearing completion.

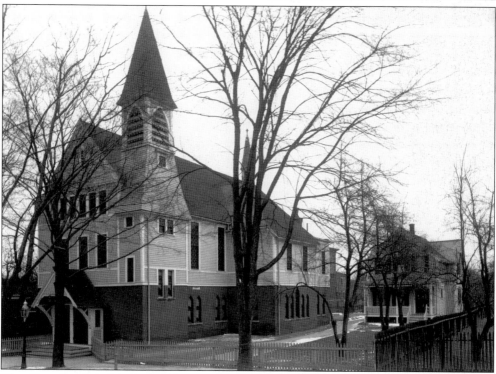

The First Swedish Methodist Episcopal Church, at 9 Stebbins Street, is shown in this photograph. Completed in 1884, it soon proved inadequate for the congregation. In 1893, the building was raised to permit the construction of a first-floor vestry. Unfortunately, the church was severely damaged by fire in April 1977.

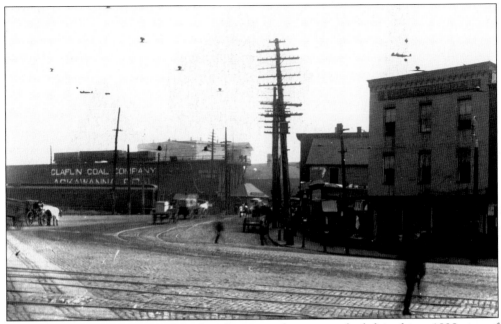

The Claflin Coal Company, at 5 Grafton Street, can be seen on the left in this *c.* 1898 view of Washington Square. The square, home to Union Station, was the transportation hub of Worcester during the heyday of train and streetcar travel. The overhead wires and tracks of the Worcester Consolidated Street Railway are evident in the photograph.

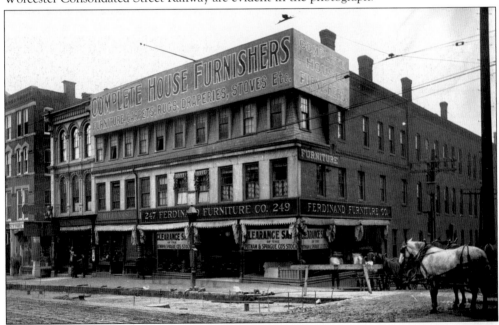

The Ferdinand Furniture Store, owned and operated by Frank Ferdinand, was located at 247–249 Main Street, at the corner of Central Street. At the time of this *c.* 1890 photograph, the company was holding a "Clearance Sale of the Putnam and Sprague Co's Stock," as advertised in the storefront windows. It appears that sidewalks were being constructed in front of the business.

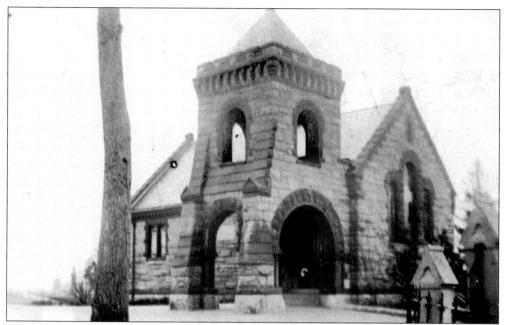

The Romanesque Curtis Chapel, which once graced the grounds of Hope Cemetery, is pictured here in the 1890s. The cornerstone of the chapel, which was named after longtime superintendent Albert Curtis, was laid in 1890. For generations, the chapel served as a beacon of quiet reflection and funeral services. The last service occurred in 1959, after which it fell into a state of disrepair. Deciding it was too costly to renovate, the city demolished the chapel in 1961.

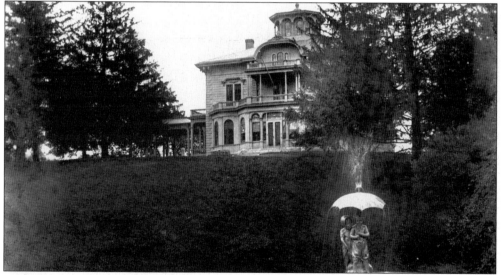

Loring Coes, famous Worcester industrialist and inventor of the monkey wrench, had this 25-room mansion constructed at 1049 Main Street, in Webster Square, in 1872. Set on a hillside, the estate sat across from his brother Aurey's residence and offered a commanding view of the Webster Square area. In 1933, the mansion was demolished. The fountain was removed and now graces a Dean Street courtyard. Recently, 1049 Main Street was home to the Worcester Ice Arena. It now houses the Arena Plaza.

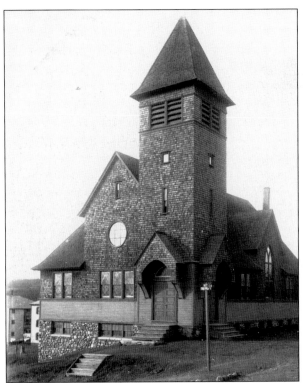

The recently completed Greendale People's Church building, at the corner of Francis Street and Bradley Avenue, is pictured in this *c.* 1896 photograph. At the dedication ceremonies held in May of that year, Dea. William Woodward of the Piedmont Congregational Church spoke of "a great future for the people of Greendale as the result of the establishment of the new church." The edifice has since been enlarged.

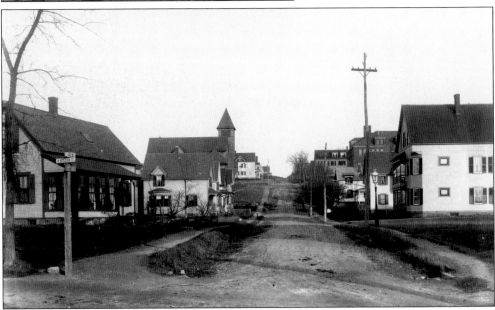

Francis Street is shown from West Boylston Street *c.* 1896. The spire of the Greendale People's Church is shown to the left, and the Greendale Elementary School can be seen to the right. Upon completion of the school in 1893, the superintendent of public buildings remarked that the structure "is located upon three streets—Francis street, Bradley street and Summit avenue—or what are supposed to be streets at no distant day, but they are difficult of access and will require a considerable amount of money and labor to make them passable."

32

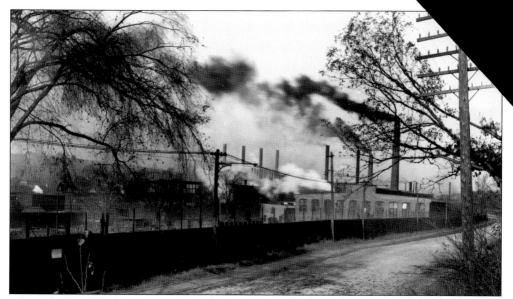

The industrial activity of the sprawling American Steel and Wire Southworks complex in Quinsigamond Village is evident in this photograph taken from Ballard Street. Opened in 1846 as Washburn and Moen, the company became a founding member of American Steel and Wire in 1899. Irish and, later, Swedish immigrants worked within the confines of what became the largest wire company in the world by 1895. The corporation closed operations at this site in the 1970s.

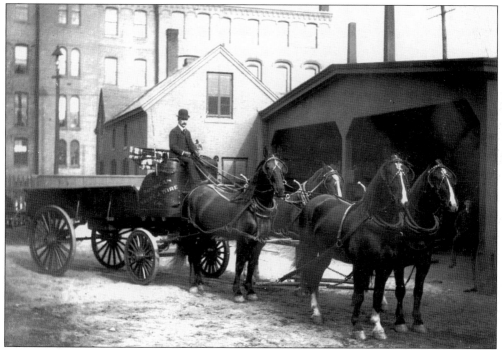

This nattily dressed teamster is seen holding the reins of his well-groomed and harnessed team of the American Steel and Wire Company, successor to the Washburn and Moen Wire Company at the north works shop on Grove Street.

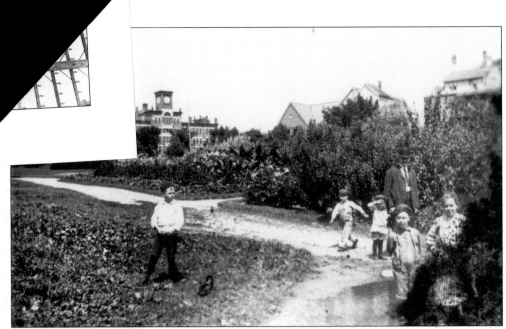

Children play close to the water's edge under the watchful eye of their guardian, in this 1890s photograph taken at University Park, now known as Crystal Park. In order to serve the needs of the neighborhood better, a wading pool for children was added in 1911 and tennis courts were constructed in 1915. The original name of the park came from its proximity to Clark University, whose only building at the time can be seen in the background.

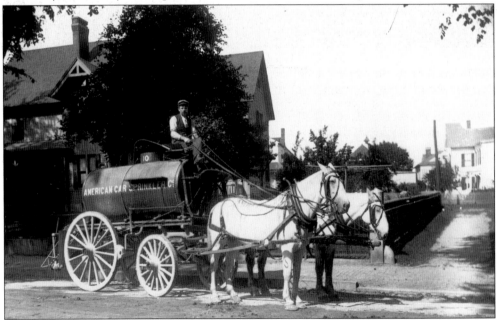

It was the goal of city government to ensure a clean city for its inhabitants. The American Car Sprinkler Company, long a familiar site on Worcester roadways, assisted in this effort by watering down streets, thereby keeping airborne dust and debris to a minimum. This, it was believed, helped promote good health. The use of horse-drawn wagons for this task was shortly discontinued when the city switched to electric railway service in 1893.

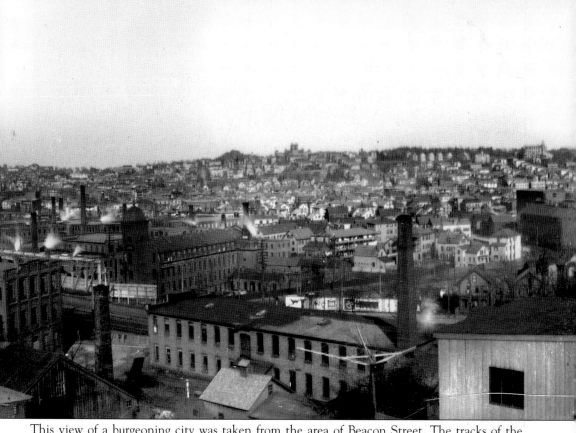

This view of a burgeoning city was taken from the area of Beacon Street. The tracks of the Boston and Albany, the Norwich and Worcester, and the New York, New Haven and Hartford can be glimpsed behind the smokestack in the lower left. The tower just above belongs to the Sargent Card Clothing factory, built in 1866 at 300 Southbridge Street on the corner of Quinsigamond Avenue. Union Hill rises in the background. The turreted buildings of Worcester Academy are on the horizon amid the rows of three-deckers.

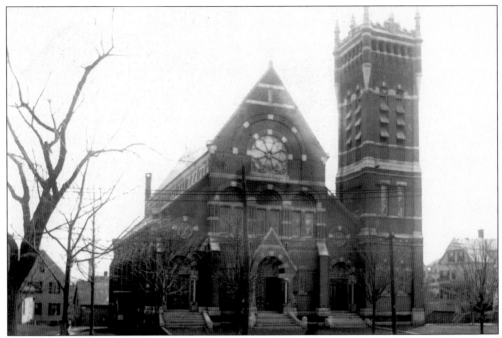

St. Peter's Church, organized in May 1884, was one of three Roman Catholic congregations formed in Worcester during the 1880s. The cornerstone of the church was laid on September 7, 1884, with great fanfare, which included a military parade along Main Street. The first mass was held in the completed basement on Christmas of that year. The church, however, was not fully completed until 1893. The ornate Victorian structure was designed by P.W. Ford of Boston, architect of many city Catholic churches.

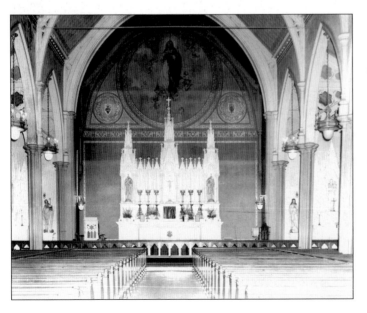

This view shows the interior of the Immaculate Conception Church, on Prescott Street. Established in November 1873, it was the fifth Roman Catholic congregation founded in Worcester. The original church was abandoned after the opening of the present edifice, which was constructed on Grove Street and dedicated in 1957.

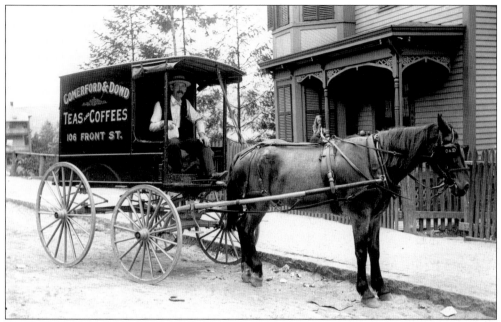

Mary J. Comerford and Thomas F. Dowd operated their retail store, specializing in coffees and teas, from 1895 to 1910. Comerford operated a similar business from 1884 until she became partners with Dowd in 1895. Shown is a Comerford & Dowd delivery wagon. It appears that the driver has a bag of coffee in his hands.

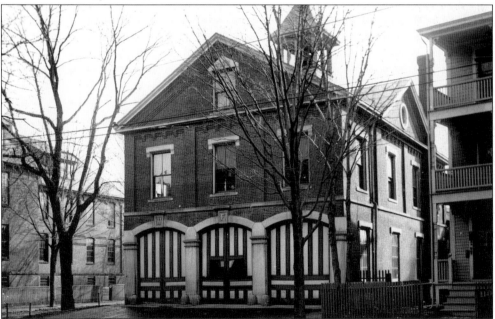

This late-1890s photograph shows the unique arches of the Winslow Street Fire Station, which was built in 1873 at the corner of Winslow and Pleasant Streets. The arches were removed in 1951, when the building was remodeled. The station was closed in 1979, with Engine No. 4 and Ladder No. 7 moving to the new station on Park Avenue. Once used as a dentist's office, it is now occupied by private business.

As the population of Worcester exploded during the last quarter of the 19th century (from 58,291 in 1880 to 118,421 in 1900), the three-decker emerged as one solution to the housing problem. Within a generation, three-deckers had been constructed throughout the city, more than 2,000 between 1890 and 1900 alone. Three-deckers dominate this 1890s view of the intersection at Maywood and Woodland Streets. Real-estate agent Henry Harmon Chamberlin was instrumental in opening this area during the 1850s. Both streets took their names from the abundance of natural woods that were originally found here.

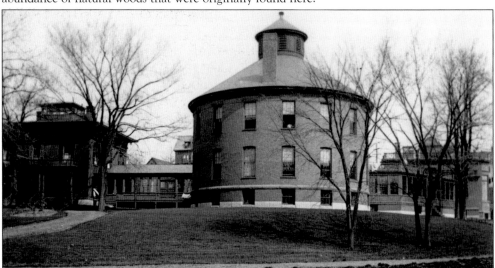

The circular Moen Ward, constructed in 1892, is seen in this view of Memorial Hospital, located on Belmont Street. To the left stands the original building, a former mansion. The hospital was organized in 1888 at the bequest of manufacturer Ichabod Washburn as a memorial to his two daughters. The original hospital buildings have since been demolished and replaced. Memorial merged with UMass Medical Center in 1998 and is now known as UMass Memorial Medical Center, with three locations in Worcester.

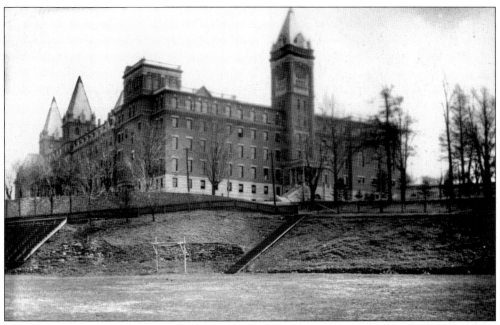

Shown on Packachoag Hill is the main building of Holy Cross College, founded by Fr. James Fitton in 1843. This site was purchased and the Mount St. James Seminary built under Father Fitton. The seminary was replaced by this structure, which was heavily damaged by fire in 1852 and rebuilt. French and Irish Roman Catholics had arrived in Worcester as early as 1824 and organized a parish church in 1841. This church, Christ Church, had become the mother church to 11 parish churches by 1900.

Built *c.* 1872, the John Street Fire Station is shown in a late-1890s view. The station was closed on December 29, 1931, amid much citizen protest. The last company in it was Chemical No. 1, and it was razed in 1954.

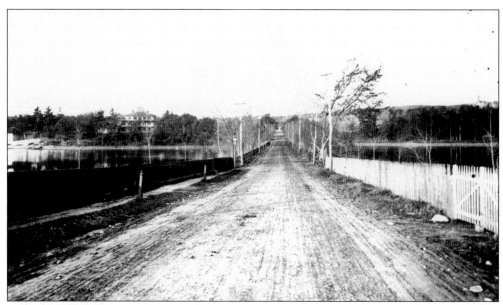

Pictured *c.* 1890 is the earthen causeway that spanned Lake Quinsigamond for more than 50 years. After several failed attempts with floating wooden bridges, this causeway was constructed on Lake Quinsigamond in 1862, virtually cutting the lake in half. Between 1916 and 1919, the causeway was replaced with the new Lake Quinsigamond Bridge. This photograph was taken from the Shrewsbury side of the lake, looking toward Worcester.

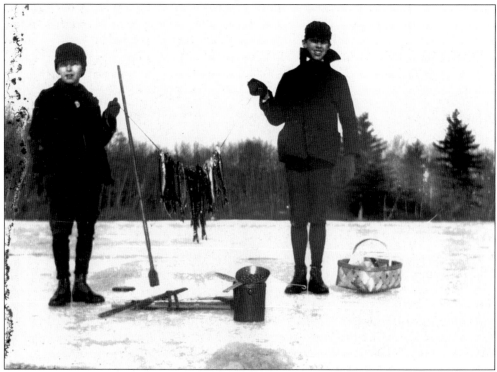

Wintertime always provided opportunities for the sportsman. These boys display their catch of what appears to be pickerel and horned pout taken from Coes Pond.

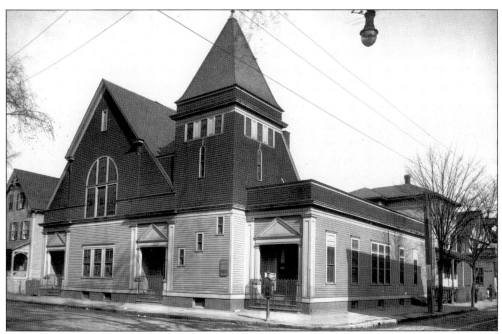

The Second Advent Christian Church was founded in 1841 as result of the Millerite prophesies of the second coming or millennium of Christ. The congregation's first church was on Main Street before this edifice (pictured in 1894) was built. The widening of Chandler Street in 1929 forced the demolition of this edifice. The congregation moved to a new site at the corner of Pleasant and Russell Streets in a new church, dedicated in 1930. Today, that church is known as the Pleasant Street Seventh-Day Adventist Church.

This unusual 1895 photograph from the Batty family shows a scene much like what could be seen today as the woman points out the reflection in the window. Then, as now, Worcester families made pets part of their home life.

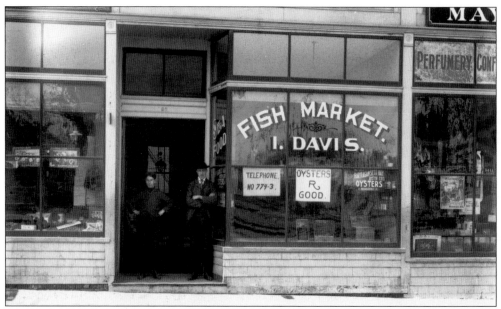

Ira Davis opened his first fish market in 1881 at 583 Main Street. This 1899 photograph shows his last market, at 81 Maywood Street. At that time, there were 18 fish markets in Worcester to meet the demand of the rapidly growing population. Notice the handwritten telephone number in the window.

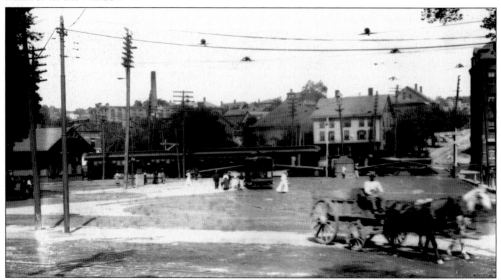

Few today would recognize this view of Lincoln Square, taken from the steps of the Worcester County Courthouse. Pictured on the left is the Lincoln Square station of the Boston and Maine Railroad, with a locomotive and two cars crossing Belmont Street. A 10-bench open trolley car of the Worcester Consolidated Street Railway is stopped for passengers while the horses of the delivery wagon turn south onto Main Street. The huge traffic problems associated with so many transportation and pedestrian usages in the square led to a series of rebuilding projects to help the flow of traffic in this six-way intersection. The railroad grade crossing was eliminated in 1955, and a rotary-tunnel system was installed in its place. This, in turn, was redrawn into today's system of stops and lights.

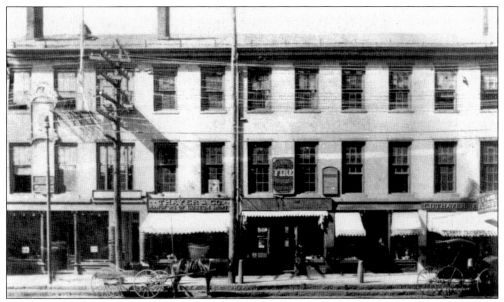

Brinley Hall, the favorite gathering place of Worcester's elite in former years, was located on Main Street between Maple and Walnut Streets. It was erected in 1836–1837 by Thaddeus MacCarty. In its early years, the third-floor hall was occupied by J.H. Moore's dancing school and, later, by the Grand Army of the Republic lodge. In 1850, the first National Women's Rights Convention was held here. Brinley Hall was razed in 1895. The nine-story State Mutual building now occupies the site.

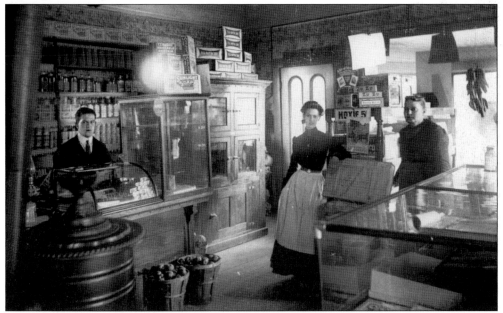

Moxie is only 5¢, in this late-1890s picture of a neighborhood store in Worcester. Apples sit in baskets for sale on the floor, and bananas hang in the front window. The two clerks and what appears to be a relative or customer, strike a very serious pose for the photographer. Stores like this were found in neighborhoods all over Worcester. Note the ornate wood stove for those cold days of winter.

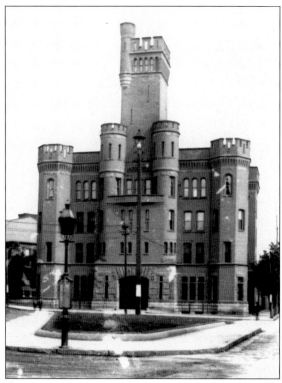

This 1890s photograph shows the armory that was built in 1889–1890 at a cost of $131,991. The architectural firm of Fuller and Delano designed both the armory and the nearby Salisbury Street Grammar School in the Romanesque style. The armory replaced the Waldo Street Armory, which was built in the 1870s but found to have serious structural flaws by the 1880s.

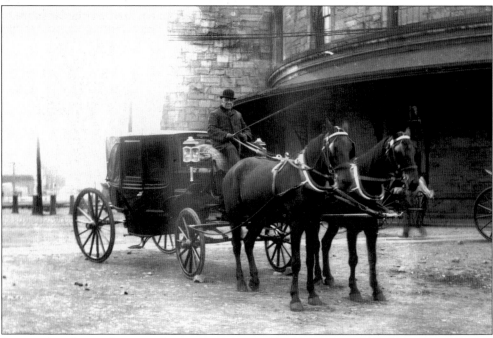

Prior to the advent of motorized taxis, carriages would take weary travelers from Union Station to various points throughout the city and county. In this c. 1890s photograph, a driver waits for arriving trains loaded with passengers. In the right background stands the immense granite base of the station's clock tower.

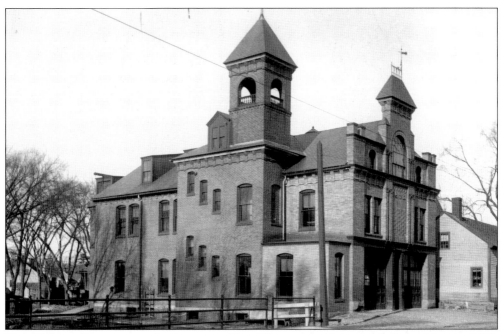

The Webster Square area, also known as New Worcester, received this fire station in 1893. Next door (hidden behind the station and the other building) was the Webster Square Schoolhouse. When torn down in 1999, the Webster Square Station was one of only three remaining active "old" stations; the other two were Brown Square and Providence Street. The newly built Webster Square Station stands as a state-of-the-art station with a similar facade.

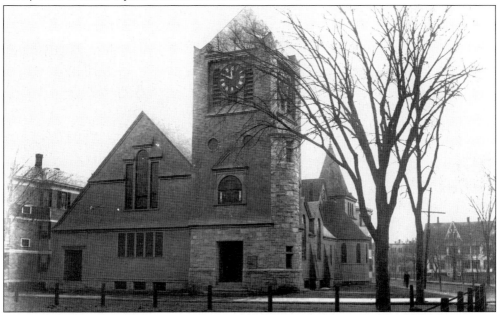

The City Missionary Society was instrumental in helping organize new churches in Worcester. The society recommended a Congregational church in the developing area near Elm Park. Park Congregational Church, established in 1886–1887 at the corner of Elm and Russell Streets, is an offspring of that effort.

Oread Institute was founded by Eli Thayer on a rise once known as Goat Hill. A liberal-minded educator, born in Mendon, Thayer was the driving force in organizing the migration of antislavery Free Soilers to Kansas and Nebraska, saving these states for the North. He designed and built this crenellated castle with the circular 50-foot towers shown in this 1880s picture. The institute opened as the Oread Collegiate Institute for Women. Here, for the first time, women were allowed to attend school and earn a four-year liberal arts degree. Following its closing as a riding school, the derelict building stood until the 1930s.

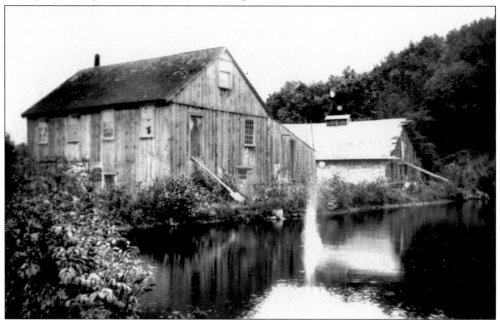

Tatnuck was the rural west side of Worcester. Development of the area did not begin until the early 20th century. The view of this old mill and the icehouse beyond does not suggest that this 1892 picture was taken in the Commonwealth's second largest city.

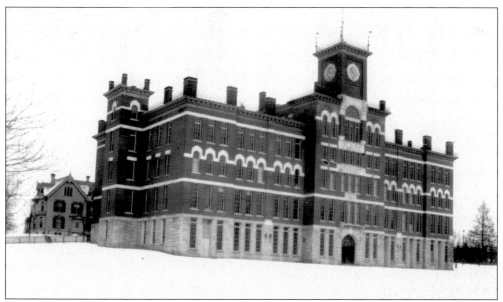

The cornerstone was laid on October 22, 1887, and Clark University opened in 1889 as a graduate school. This photograph shows the first building, which had four stories on each side and five in the center. Measuring 204 feet by 114 feet, it contained 90 rooms. In the tower is a clock given by the citizens of Worcester. In an 1893 publication, Clark University was called "a philosophical faculty where students leaned heavily on research along with their instruction." Pres. Theodore Roosevelt and Dr. Sigmund Freud visited to give lectures and speeches. Prof. Robert Goddard, a noted rocket scientist, was long a member of the faculty.

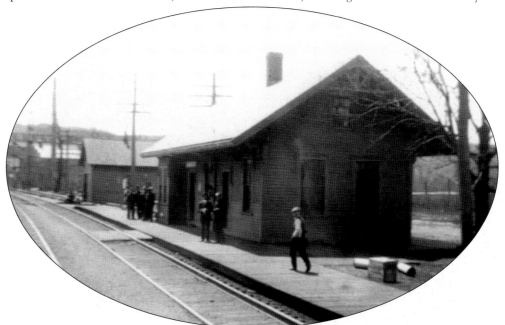

This is an early view of the Jamesville station on the Boston and Albany Railroad. Daily, 36 passenger and 25 freight trains passed by this station, which was located west of Stafford Street next to James Street.

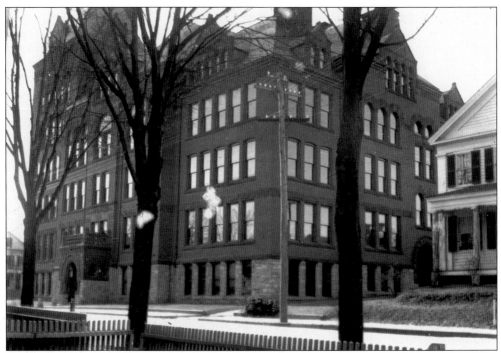

The English High School, built for $190,000 at the corner of Chatham and Irving Streets, is pictured a few years after its celebrated September 1892 opening. A dramatic change in the city's high-school system occurred in 1914: the English High School disbanded, and the students and staff of Classical High School transferred to those quarters. The former Classical building on Walnut Street was enlarged and became home to the new Commerce High School, which specialized in commercial and business training—skills that were a necessity in the age of industry. Classical was closed in 1966 upon the opening of Doherty Memorial High School, and the building was turned into the administration building of the school department.

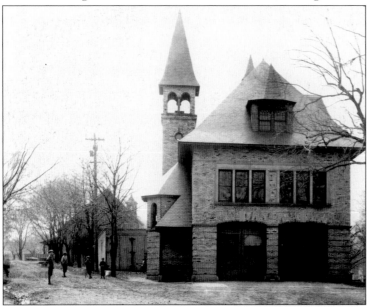

This c. 1899 photograph shows dirt streets and some children playing outside of the Bloomingdale (Brown Square) Fire Station, which housed Engine No. 6. Built in 1894–1895 at a cost of $12,420, the station added protection for a growing population. It is one of two "old" stations still active; the other is Providence Street.

Old South Congregational Church is successor to the 1763 First Church, which stood on the Main Street end of the common until the church was torn down in 1887. The congregation then built this Romanesque Revival church at the corner of Main and Wellington Streets. As the years passed, the congregation found itself in a deteriorating neighborhood and finally sold the building and merged with the Tatnuck Congregational Church, forming the present First Congregational Church on Pleasant Street. Today, the altered structure houses apartments.

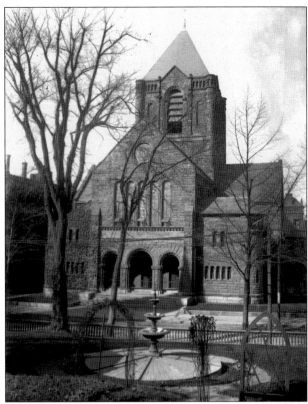

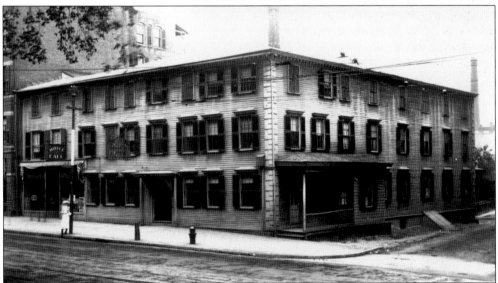

The Exchange Hotel, built in 1784 and first known as the United States Arms, was located at 93 Main Street. It was originally built as with two stories, with a third added in the early 1800s. Stagecoach travelers frequented its many rooms throughout Worcester's early years, using the hotel as a hub for their travels. Two famous guests were Pres. George Washington, who visited on October 23, 1789, and France's General Lafayette, who visited in 1825. The hotel closed on May 1, 1895, after 111 years of operation.

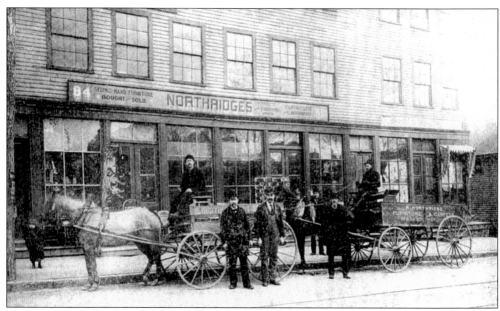

During the early days of the Northridge Furniture Company, the deliveries and pickups had to be made with wagons, as shown in this *c.* 1890 photograph. Robert Northridge moved the business to its permanent home, at 166 Southbridge Street, where it remained for decades.

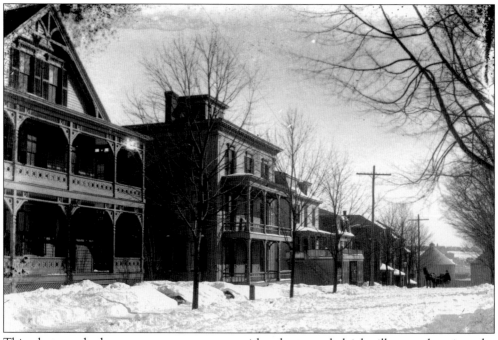

This photograph shows a snowy streetscape with a horse and sleigh silhouetted against the Worcester Gas and Light Company's round brick storage building in the right background.

Dewey Street Baptist Church, organized in 1872, is the third oldest Baptist church in the city. Earlier meetings of this church had been held in the Mason Street schoolhouse in 1867. This photograph shows the new church, at 136 Dewey Street at Austin Street *c.* 1890. The demographics changed rapidly in the area, and by 1952, Immanuel Baptist Church occupied the structure. A Fleet Bank now occupies the site.

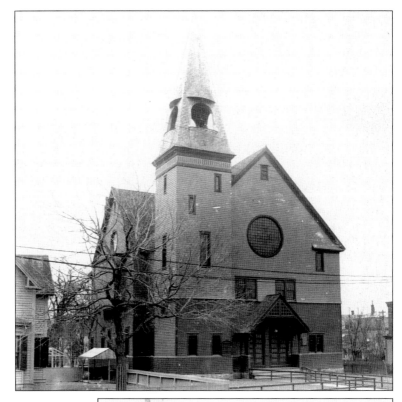

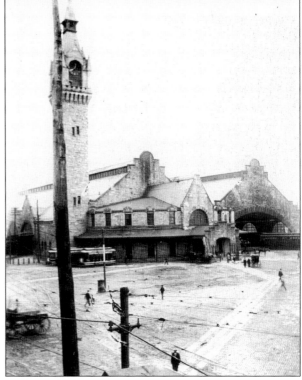

Coinciding with Worcester's industrial growth was the city's growing importance as the transportation capital of the county. Worcester's impressive Union Station, opened in 1875, played host to the region's major rail lines and served as the entry point for thousands of immigrants. The grind of daily life at the station is symbolized in this 1890s photograph. At the rail entrance to the station, workers tend to a locomotive while a delivery wagon sits nearby.

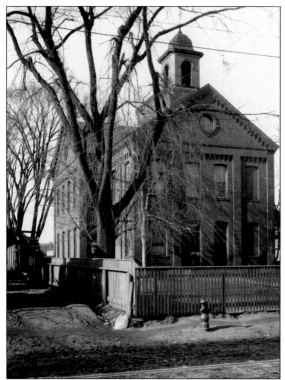

The Webster Square Schoolhouse was adjacent to the Webster Square Fire Station, as shown in this 1890s photograph. Occupied in September 1858, the school served the Webster Square area until it was severely damaged by heavy flooding in March 1936. After its closing, the building reverted to a Work Projects Administration recreation hall during the New Deal era of Pres. Franklin D. Roosevelt. It later housed a laundry business. In July 1962, the former schoolhouse was torn down to make way for a parking lot.

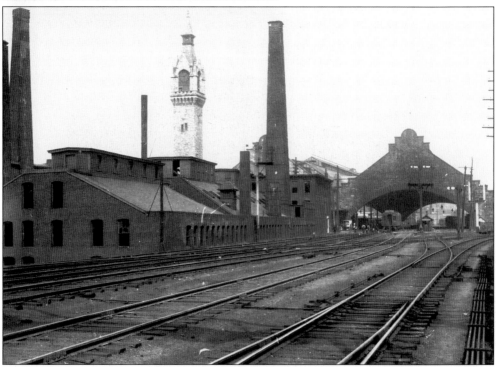

Union Station provided multiple railroad facilities for passengers and freight. This early photograph offers a unique angle from which can be seen the multiple tracks entering the station.

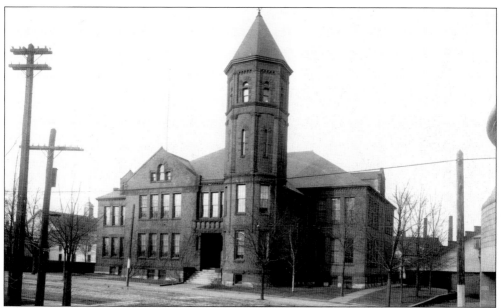

Much fanfare heralded the opening of the Salisbury Street Schoolhouse in September 1890. *Light*, an early Worcester publication, described the school as "the finest building Worcester has ever erected for school purposes." The tower was situated to afford the traveler on Harvard Street to Salisbury Street the best possible view of this feature. In 1911, the school was reorganized as North High School and, in 1915, was enlarged with an addition. Currently, the building is part of the North High Gardens condominium complex.

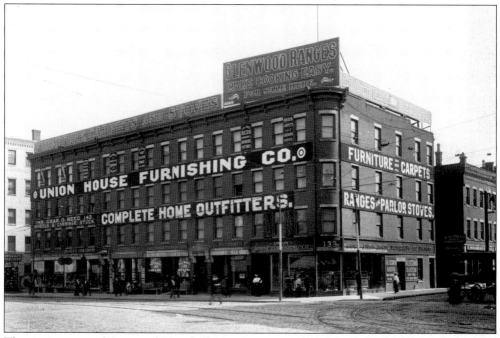

The intersection of Front and Trumbell Streets was once home to the Union House Furnishing Company, a large home goods establishment. This section of Front Street fell to the wrecker's ball during the construction of Worcester Center Galleria in the late 1960s.

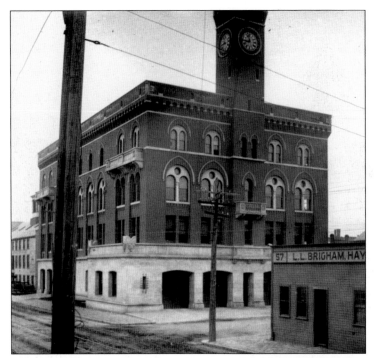

This photograph of the Mercantile Street Fire Department headquarters was taken shortly after the building was constructed in 1899. A local Main Street architect, George H. Clemence, designed this building, which stood until August 1955, when it was demolished for a municipal parking lot. The Lucius L. Brigham grain business (foreground), at 57 Foster Street, began in 1886 at 105 Front Street and continued until 1901.

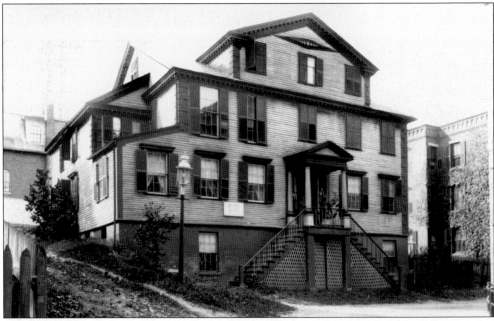

This oft published photograph of the Isaiah Thomas House offers the best view of the home of one Worcester's most influential early businessmen. Isaiah Thomas (1749–1818), fleeing censorship in British-occupied Boston in 1775, moved his printing press to Worcester. His business prospered, and Thomas built this house on Harvard Street in 1783. Eight years later, he gave the land for the Worcester County Courthouse. The later expansion of the courthouse infringed upon his property until it was necessary, in 1923, to tear down his house to provide for more court facilities.

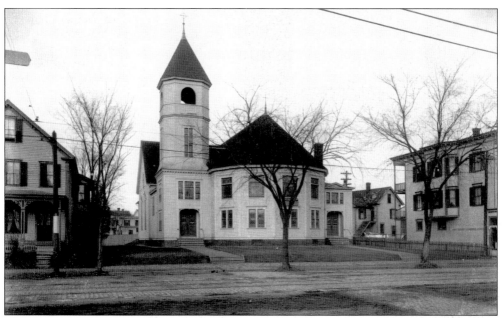

There were two Methodist churches in the Webster Square area. In 1892, the Park Avenue Methodist Church (founded in 1860) and the Trowbridge Memorial Methodist Church joined to build the new Webster Square Methodist Church, shown here. This structure was destroyed by fire, and a new church, the present Aldersgate United Methodist Church, was erected in 1967.

Three-deckers dominate Park Avenue, popularly known as "the Boulevard," in this view from the intersection of May Street looking north toward Chandler Street. Traffic consists of a few horse-drawn wagons. The tracks of the horsecars can be seen in the street, while the towers of the Worcester Slipper Company and the Harrington and Richardson Arms factory can be seen in the distance. The three-decker that stands second from the left now houses Cactus Pete's Restaurant.

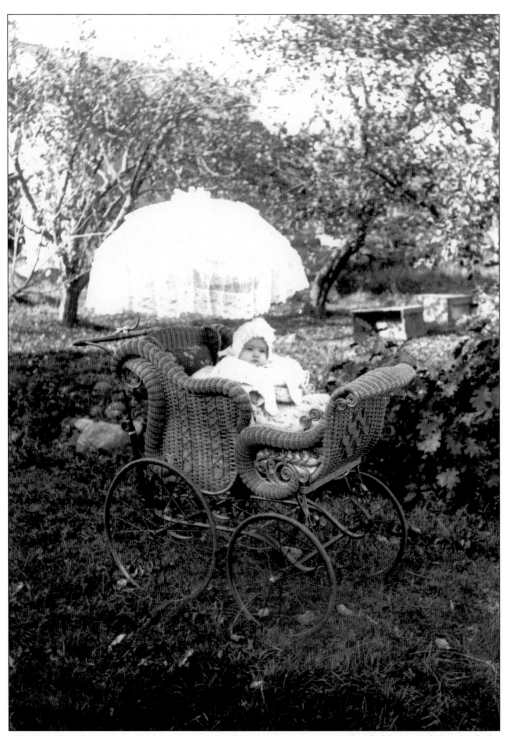

This bucolic view captures the essence of a late-Victorian scene of a child in an elaborate baby carriage in the yard of a June Street house.

Three
1900–1909

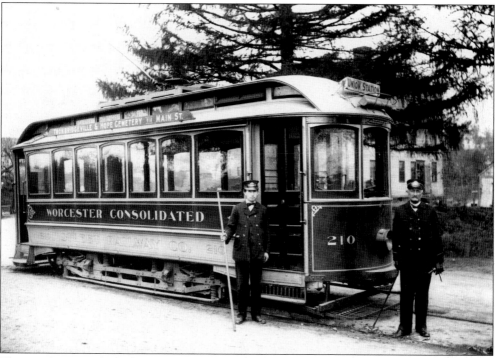

The motorman and conductor of Worcester Consolidated Street Railway car No. 210 pose at the end of the Hadwen Park line. In 1913, the track was extended to Knox Street to provide service to the community of Trowbridgeville and the neighboring cemetery. The motorman holds tools used in switching rails while the conductor holds the trolley switch pole, which reversed the power trolley pole from front to back, allowing the trolley to reverse direction. This 20-7-type trolley car was acquired by the Worcester Consolidated Street Railway in 1899. Trowbridgeville was named after Dea. William Trowbridge, a Revolutionary War soldier who lived at the intersection of Webster Street and Hope Avenue. His farm is now part of Hope Cemetery.

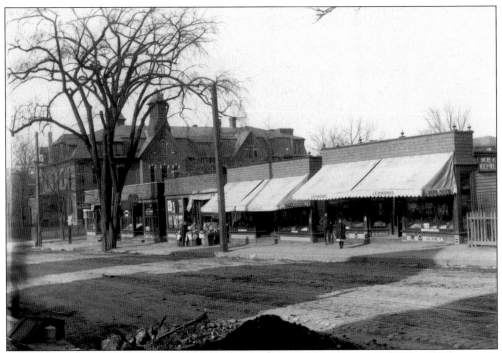

This early-1900s photograph shows George Lehmann's grocery store at 99 Belmont Street, near Oak Avenue. Lehmann opened his business in 1900 and, in 1913, moved to 205 Belmont Street. This area is now the site of Umass Memorial Medical Center. Belmont Street School can be seen in the background.

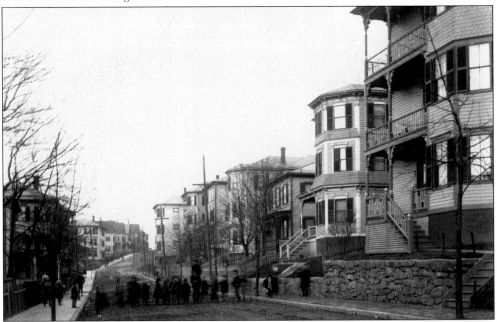

The first decade of the 20th century saw the continued march of three-decker houses over the hills of Worcester's east side. Note the lack of utility lines. An 1899 Worcester ordinance relegated these unsightly utilities to the backyards of all the houses within two miles of city hall.

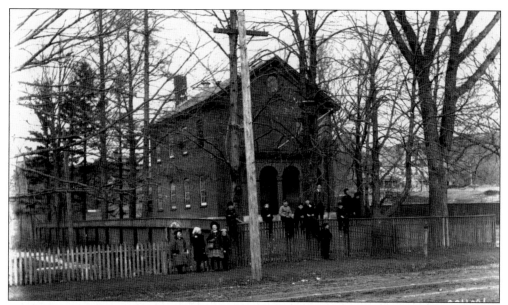

Students gather around the neighborhood schoolhouse *c.* 1900. The Tatnuck Schoolhouse, dedicated in October 1859, was constructed at the corner of Chestnut Street (now Chesterfield Road) and Pleasant Street. The building was closed after the opening of the new Tatnuck School in 1910. Although used as a school on an intermittent basis after its closing, it was torn down to make way for the Tatnuck Fire Station in 1924.

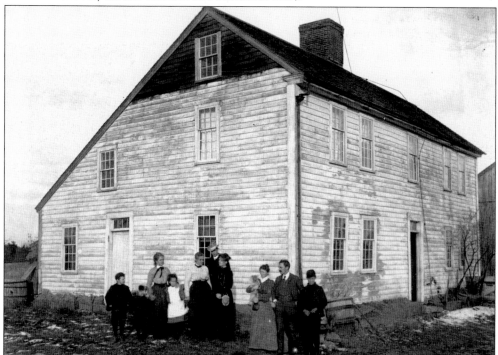

Saltbox-style houses were popular in New England before 1780. The name saltbox comes from the long rear slope of the roof, which is similar to a box of salt. This photograph of a family gathering, probably at the largely unpainted "old homestead" in Tatnuck, was taken *c.* 1905.

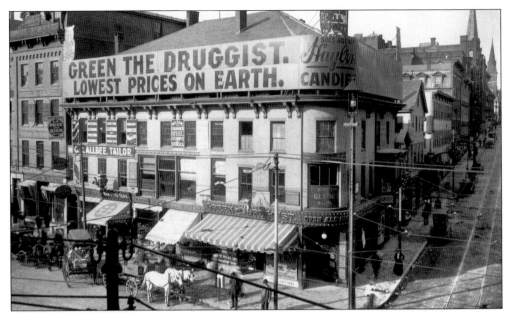

Shoppers at Harrington corner could not have but noticed the large advertisement of Henry L. Green's drugstore, at 430 Main Street, on the corner of Pleasant Street. As the sign advertises, the establishment was open all night, making it a forerunner to today's 24-hour convenience stores.

Across the street from Green the Druggist was Fergus Easton's establishment, at 428 Main Street. Easton's was one of the largest and most popular newsstand-and-stationery stores located downtown. Opened in 1893, it remained popular for nine decades, closing on July 31, 1964. In this c. 1905 photograph, the bustling activity of Harrington Corner is evident in the pedestrian traffic and approaching streetcars.

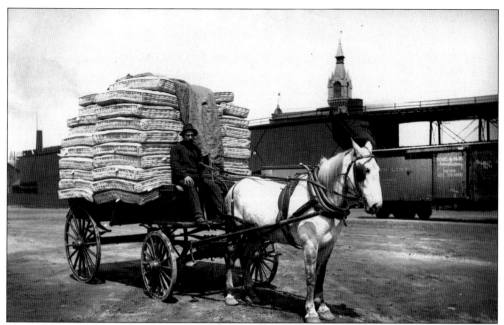

A wagonload of mattresses from the Shrewsbury Street company of John J. Griffin passes through Washington Square, in this *c.* 1905 photograph. According to an advertisement for the *Worcester City Directory*, the company manufactured and dealt in "mattresses, feathers, curled hair comforters and bedding of all kinds." In 1905, the city housed three such concerns.

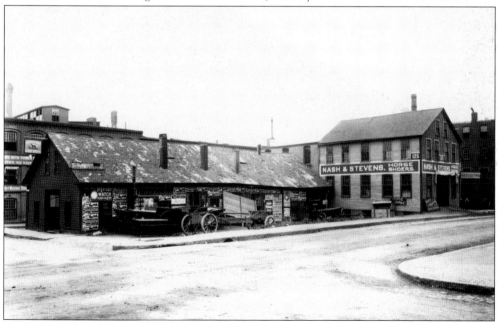

Several horse-related businesses occupied 125 Commercial Street *c.* 1905. Nash and Stevens were farriers, or horseshoers, as were Murphy and Mungovan. The third occupants, John Fanning and Son, were horse clippers. This photograph shows the buildings that housed these establishments, at the corner of Commercial and Exchange Streets. To the far left lies the factory of the Davis and Buxton Stamping Company, at 3 Cypress Street.

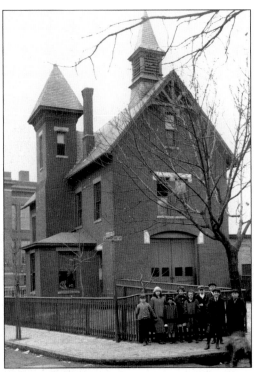

Youngsters pose in front of the Lamartine Fire Station, in this early-1900s photograph. Cognizant of the fire disasters in Chicago and Boston around that time, the city moved to expand the number of firehouses. This station, built in 1873, was designed by the local architect firm of Earle and Fuller. It was closed at the end of December 1959 and razed.

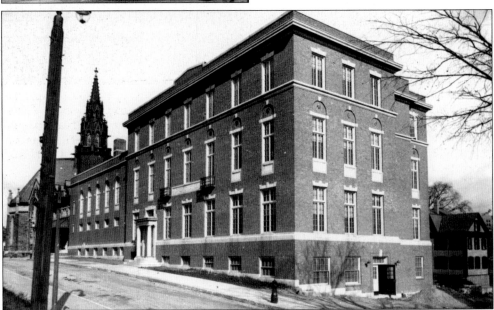

Pictured with the tower of the First Baptist Church in the background, the new Worcester Boys Club near was near completion when this photograph was taken. In 1913, land at the corner of Ionic Avenue and Beacon Street was purchased, and the following year, work began. Dedication ceremonies took place in October 1915. By the spring of 1917, membership had increased to more than 2,400, making the Worcester Boys Club one of the largest in the nation "providing and maintaining rooms for the improvement of the moral, physical, intellectual and social nature of boys."

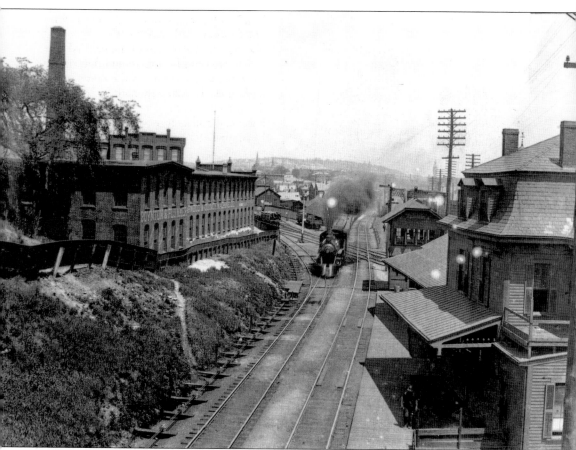

In this unique 1905 photograph, a train on the Boston and Albany line passes through the junction with the Norwich and Worcester Railroad. The junction station is to the right. To the left stands the Boynton and Plummer Machine Shop with its neighbor, the Harwood and Quincy Machine Company, on Lagrange Street. The property surrounding the rail lines quickly became a sought-after commodity by area industrialists, as goods could be shipped easily and quickly to and from the factories.

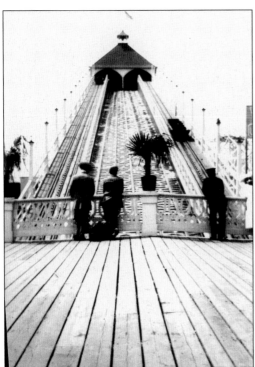

The highlight of a visit to the White City Amusement Park for thousands of youngsters was the early flume ride. The people shown in this photograph appear to be waiting for their friends to return with tales of the thrilling ride.

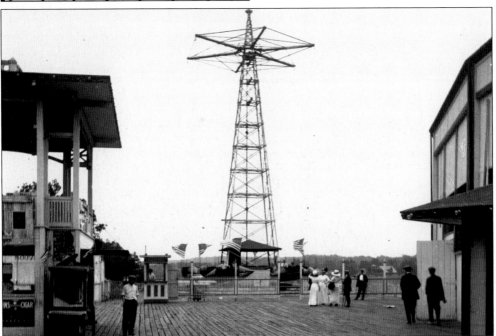

White City, on the Shrewsbury side of Lake Quinsigamond, quickly became the most popular destination for residents after it opened in 1905. The brainchild of Horace Bigelow, the park remained an entertainment attraction until its closing on Labor Day of 1960. Pictured is a ride known as the Whirl of Captive Airships. The "airships" were attached to a rotating tower by cables. At top speed, the passengers traveled above both park and lake.

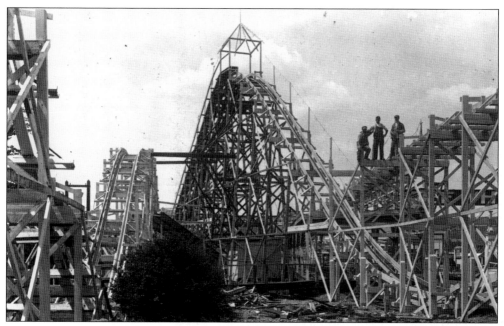

The White City Amusement Park roller-coaster ride was a major attraction. Generations of Worcesterites enjoyed the exhilarating ride, with its dips and dives, on a warm summer night. This photograph shows what appears to be construction on the new ride.

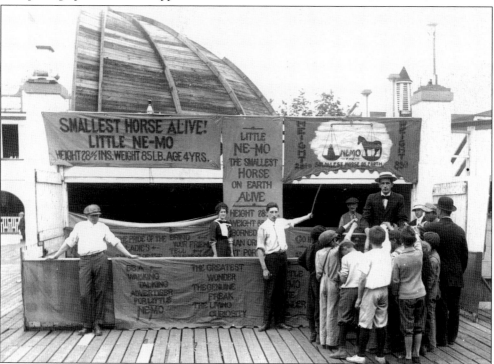

Children compete for a view of "Little Ne-Mo, the Smallest Horse Alive," in this early photograph taken at White City. Throughout its existence the popular amusement park featured hundreds of attractions, including oddities such as this.

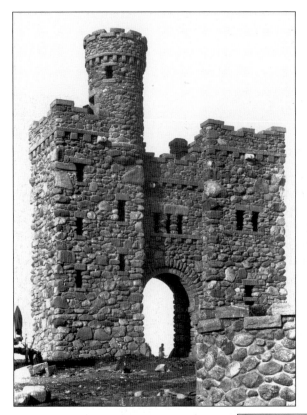

Photographs chronicling the construction of Bancroft Tower are rare. In this view from 1900, only finish work remains; the tower and accompanying emplacements are essentially complete. Prominent resident Stephen Salisbury III commissioned the construction of this tower to memorialize the friendship between George Bancroft and Salisbury's father. Bancroft, born in Worcester in 1800, was a well-known figure in 19th-century America. A prominent statesman, politician, and horticulturalist, Bancroft delivered the eulogy at Pres. Abraham Lincoln's funeral. One of his greatest contributions to the country was his founding of the U.S. Naval Academy at Annapolis.

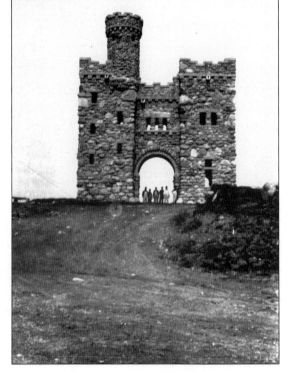

Workmen pose under the nearly completed Bancroft Tower in 1900. Upon its completion atop Bancroft Hill, the tower offered one of the most commanding views of the city. Unfortunately, the tower is now closed to the public.

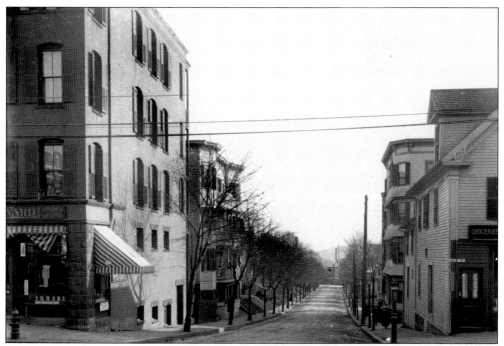

A neat and orderly Kilby Street is shown in this 1905 picture taken from Main Street. In the far distance, the smokestacks of the Worcester Corset Company can be seen.

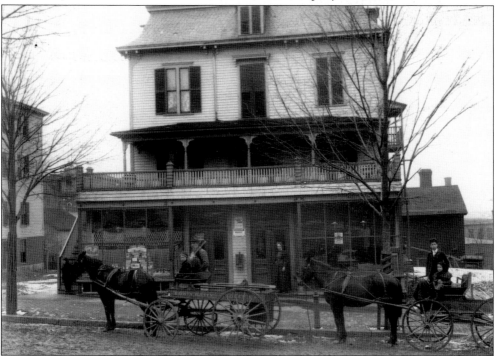

In this 1904 photograph, grocer Edwin Batty poses at the reins of his express wagon and his wife stands in the doorway of his store at 55 Oread Street. The light wagon, with its open rear space, was used for deliveries. The Batty family occupied the upper floors of the building.

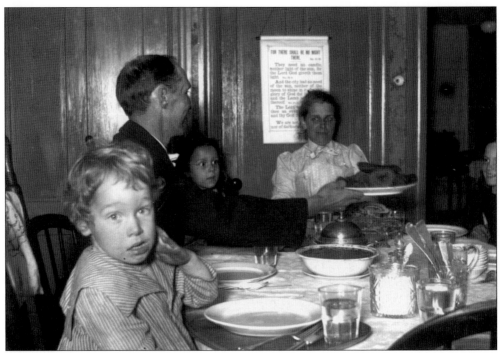

This early-1900s domestic scene shows a supper being served in the Batty household to an appreciative family.

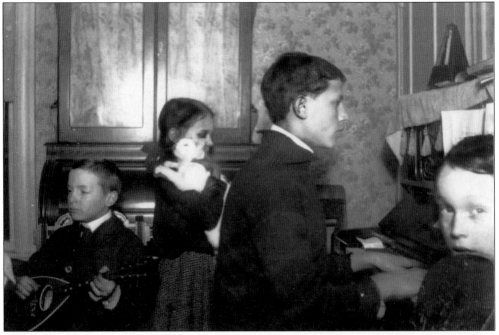

This 1905 photograph offers a backward glance at one of the domestic pleasures in a city where an evening of piano and song was common. As one young man concentrates on playing the piano, his brother, playing the violin, looks at the photographer. In the chair, another brother plays the mandolin as his sister listens and holds on to her cat.

St. Matthew's Episcopal Church, the stone Gothic Revival–style church at the corner of Southbridge and Cambridge Streets, is noted for its elegant Tiffany stained-glass windows. Pictured in 1901, it was the first in a plan calling for the establishment of four missions—one for each quarter of the city—to be named after the four evangelists. The parish was founded in 1871, and a church was settled in 1881. Matthew Whittall, the owner of the nearby Whittall Mill and an Episcopalian, encouraged the building of this church. It is said that at the wedding of his daughter, a carpet for the wedding party to walk upon was laid from his house, on the opposite side of Southbridge Street, to the front door of the church.

Clark University grew rapidly after its founding. The academic building seen here, the third building erected on campus, was formerly the library. Founder Jonas Clark had originally given $100,000 for a library fund. He later added to this, and in 1901, the architectural firm of Frost, Briggs and Chamberlain designed this classical example in the so-called College Gothic style, prevalent in England. Also shown in this rare photograph is the university laundry and tailor shop and a small grocery store. The wagons of the John P. Squire Wholesale Provision Company, located at 199 Summer Street, appear to be making a delivery.

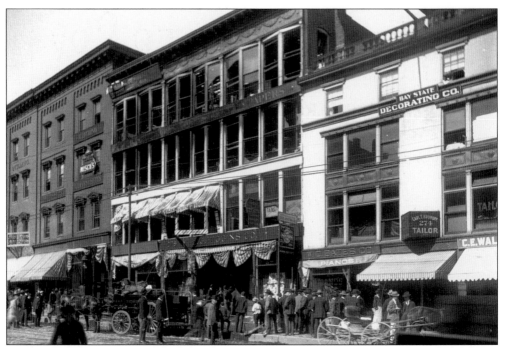

Curious onlookers gather in front of the block housing the *Worcester Daily Spy* after a disastrous fire destroyed the newspaper's mechanical plant in 1902. The struggling company never rebounded from this loss, and on May 31, 1904, the *Spy* ceased publication, ending a tradition that had begun with Isaiah Thomas in 1770, when he began publication of what was then called the *Massachusetts Spy*.

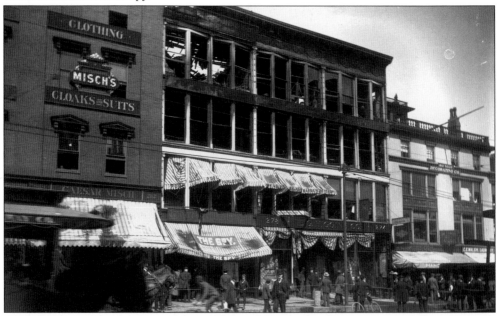

A streetcar passes by the ruins of the 1902 fire. Several other businesses were affected as well, including Johnson and Sundh, a Swedish tailor shop, the E.G. Higgins Company, a wallpaper and home-decorating store, and the barbershop of Henry Walker.

THE WORCESTER SPY.

CHARLES NUTT, Publisher.

The Spy lost its Type, Machinery and Mechanical Equipment by
fire last year.

IT HAS *RISEN FROM THE ASHES* WITH A

New and Larger Plant.

The Spy is giving its Readers a

BETTER NEWSPAPER

THAN EVER BEFORE.

THE WORCESTER SPY

REACHES THE BEST CLASS

OF READERS IN THE STATE.

——IT IS THE——

Oldest Newspaper in Massachusetts. It is the Best for the
Home. It Contains the Fullest Telegraph News,

Having two Associated Press wires. It has a full corps of county
correspondents, who send daily letters covering all the events of
real importance. It covers the city news better than any other
Worcester paper.

It will be delivered in any part of the city by the
Spy's own carriers for $6.00 a year, $8.00
a year including Sunday and Daily.

Despite this 1903 proclamation of emerging from the fire a "better newspaper," the *Worcester
Spy* never recovered from the fire and, on May 31, 1904, ceased publication.

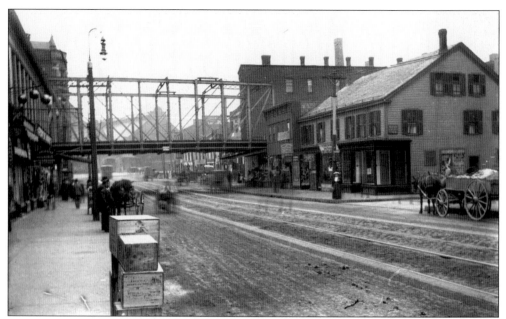

A view from under the railroad viaduct bridge shows a lively street scene at the beginning of the 20th century; the cavernous Union Station arrival hall (in the distance) dominates this area of Front Street. Everything shown here was demolished in the urban renewal phase of the 1960s and was replaced with the Worcester Center Galleria.

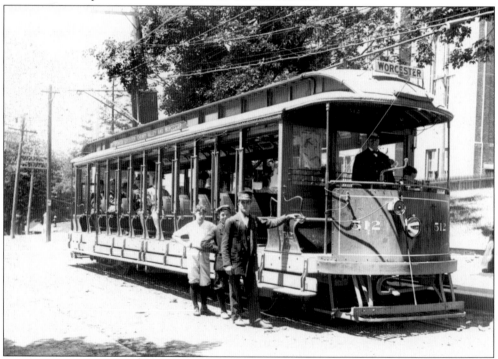

Summer brought out the open trolley cars, which provided the passengers a cooling ride. This 15-bench Stephenson trolley car was bought by the Worcester Consolidated Street Railway in 1907. It is shown inbound on the Spencer-Leicester-Cherry Valley line to Worcester.

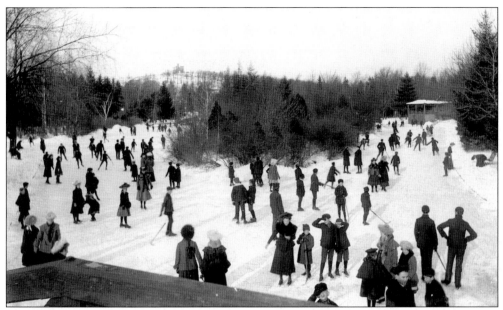

According to many sources, Elm Park was the first tract of land in the country that was set aside for park purposes (1854). Due to the efforts of the colorful Edward Winslow Lincoln, the park quickly became a showpiece and the most popular destination for residents. As one can see in this *c.* 1900 photograph (taken from one of the park's bridges), crowds flocked to the park on cold winder days to play hockey, to skate, or to walk the grounds. Bancroft Tower can be seen in the distance.

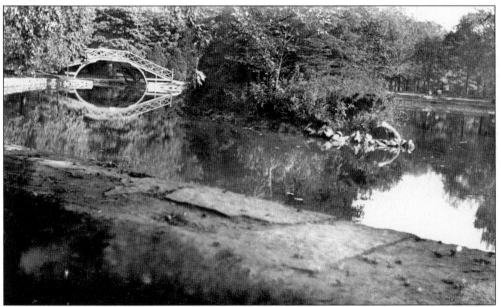

Elm Park's 88 acres evolved from land purchased by the city in 1854 as a "new common." In 1870, Edward W. Lincoln was appointed to the Shade Tree and Public Grounds Commission and was joined by Obidiah Hadwen (Hadwen Park) and Stephen Salisbury III (Institute Park). Lincoln's vision of a public park turned a swampy bog into a Victorian delight of trees, walks, and ponds spanned by a moon bridge of the Chinese style.

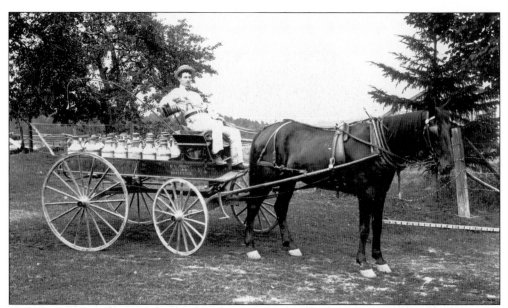

This *c.* 1902 photograph captures a milkman posing with his wagon and horse. Notice the approximately 30 large metal milk containers, which indicate that this was not a house delivery route. On the wagon is painted "E.L. Roy, License 133, Worcester." Emil L. Roy began his milk business at 400 Grove Street in 1900 and continued until 1907, closing his business at 313 Lincoln Street.

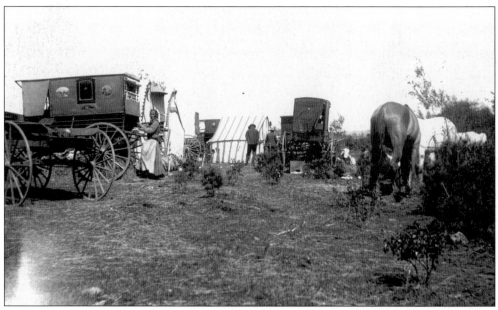

A Gypsy encampment is shown in this *c.* 1900 photograph, labeled "Tatnuck." At that time, bands of Gypsies roamed the country, offering cheap transient labor and entertainment.

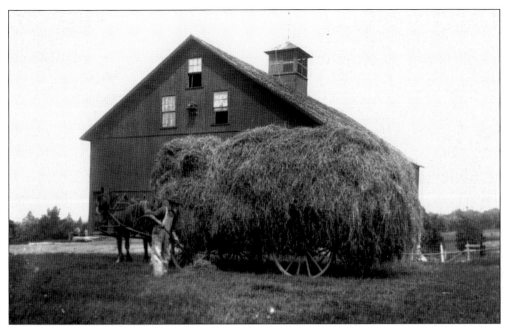

This photograph captures a bucolic Tatnuck farm scene from the early years of the 20th century. The elderly farmer is gathering the scatterings of hay from the wagonload before bringing the hay into the well-kept barn.

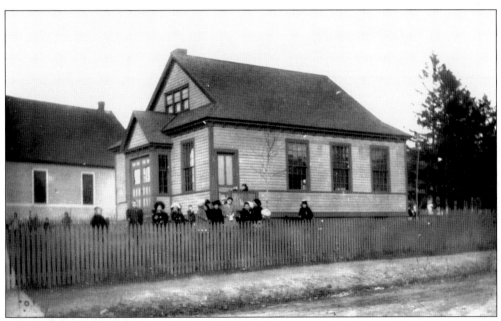

Children gather in the yard of the Jamesville Schoolhouse c. 1906. This wooden structure was opened on James Street in 1887 and was moved to the corner of Clover and Montello (now Prentice) Streets in 1903 due to the widening of James Street and the subsequent trolley line construction. The building was closed upon the completion of the Heard Street School in 1932. One of three wooden schoolhouses remaining in Worcester at the time of its closing, it was ordered demolished by the school committee in February 1933.

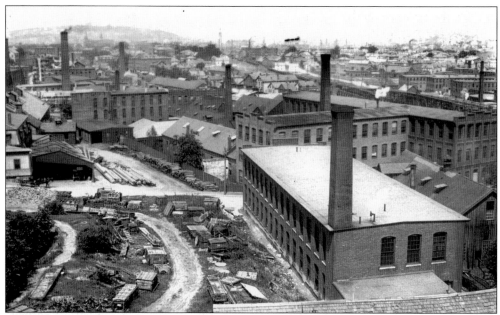

The industrial expansion of Worcester is clearly shown in this 1902 winter scene looking northeast. Numerous factories were established along the rail line parallel to Canterbury Street. The tower of the old Union Station, partially destroyed by fire in 1911, rises in the far center.

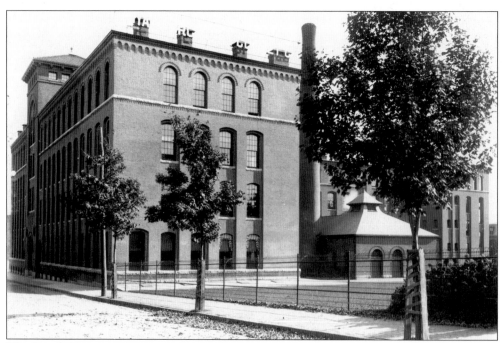

The Royal Worcester Corset Company, located at 30 Wyman Street, was founded by David Hale Fanning in 1861. At its height, the company employed some 2,000 people and was the largest corset manufacturer in the world, with offices in Sydney and London. As the demand for corsets declined, the company shifted to other forms of undergarments. It was finally forced to close in 1950. The former factory complex now houses apartments.

In 1905, the businesses in this now demolished building at 891–895 Main Street included H. Ballou and Company, the Mary Kellell millinery, the Chin George Sing laundry, and the P.T. Morey sewing machine business.

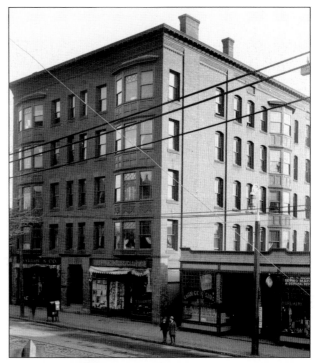

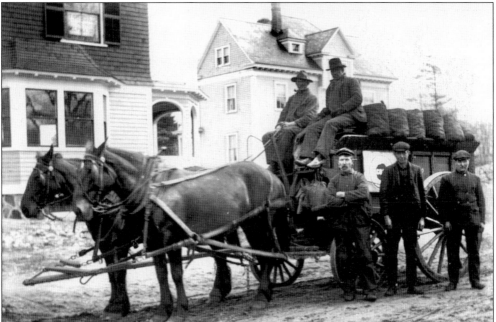

Coal-burning ranges and furnaces were used in most Worcester homes. Every three-decker had its rear piazza coal shed. In this 1905 photograph, the delivery men working for the Morris C. Boyd and Brothers coal dealers pose with a load of bagged coal. The company operated at three locations, delivering coal both bagged and in bulk. Usually, two men would haul the bagged coal up the stairs of the three-deckers to the coal shed. Bulk coal for the furnace was delivered into the cellar bin by chute from the wagon.

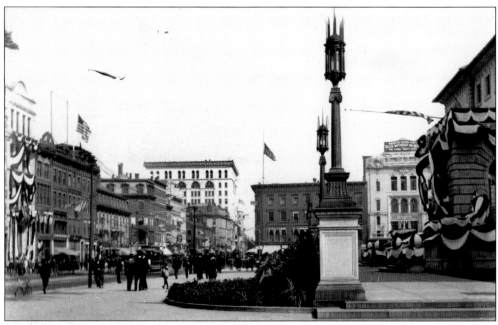

The photographs on these two pages capture Worcester in a period of national mourning during September 1901. Flags are shown at half-mast, while city hall and surrounding buildings are adorned with patriotic bunting. On September 6, 1901, Pres. William McKinley was shot while greeting spectators at the Pan American Exposition in Buffalo, New York. After lingering for six days, the president died from his wounds.

Brewer and Company, on neighboring Front Street, is bedecked with the national colors in honor of the assassinated President McKinley. A close look at the store's display window reveals portraits of the president. Edwin Avery Brewer entered the business as partner in 1888 and, by 1891, was the sole owner. On December 8, 1897, this new building was opened to the public and all 33 employees.

The Central National Bank on Main Street is adorned with the national colors following the death of Pres. William McKinley, whose picture can be seen displayed in the store windows on each side of the bank.

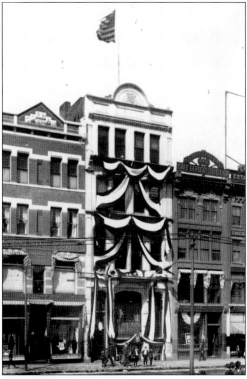

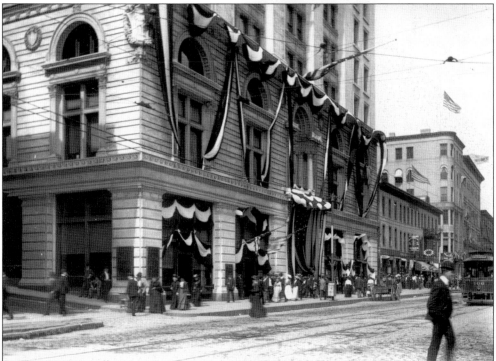

Pedestrians pass by the State Mutual Life Assurance Company, draped in honor of the president, while the flag flies at half-mast in the background.

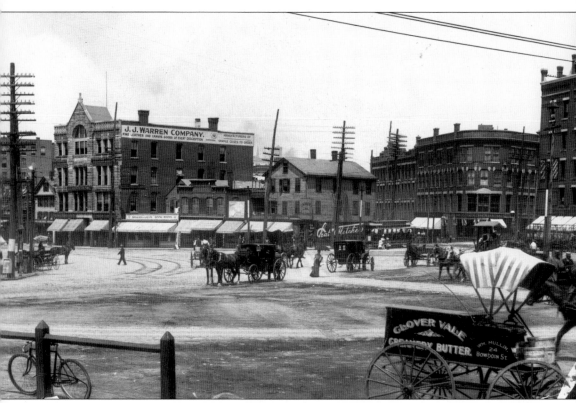

This *c.* 1902 picture of a busy Washington Square shows an area very different from the intersection we see today. The tall building on the right contained the Darling and Rhodes concern, which began in 1897 as a supplier of sundries, milk bottles, rubber goods, and many other home and business goods. The four-story building to the left housed the J.J. Warren leather goods company, which a year later moved to Austin Street. The building to the right of center with the rounded facade held the Hotel Albany (at the corner of Summer and Foster Streets), which began operation in 1901.

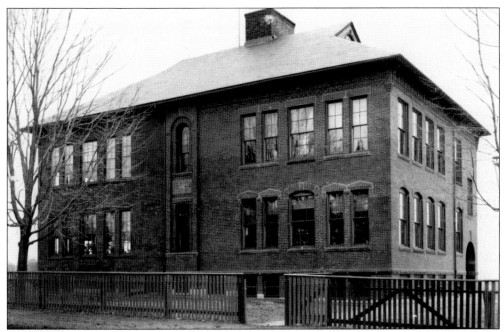

The Ludlow Street School, originally known as the Valley Falls Schoolhouse, is shown shortly after its 1905 enlargement. Occupied in 1881, the schoolhouse closed after the completion of New Ludlow Street School in 1963. Subsequently used by the town of Leicester for school purposes and by the Worcester Building Department as a warehouse, the building was eventually demolished.

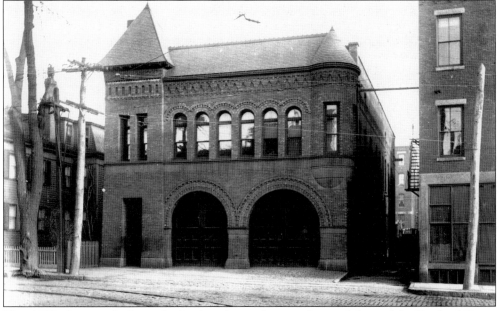

This 1900 photograph shows the brick arches and turreted second floor of the Portland Street Fire Station, built in 1892, at a time when the fire department consisted of 57 permanent and 103 call firefighters. It was demolished in 1957 for urban renewal in the Salem Street redevelopment project.

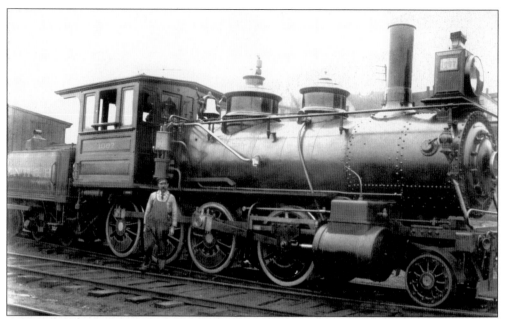

In the Worcester yard, the engineer of locomotive No. 1007 stands beside his engine of the New York, New Haven and Hartford Railroad. This railroad was one of seven major railroads that served Worcester and the surrounding communities.

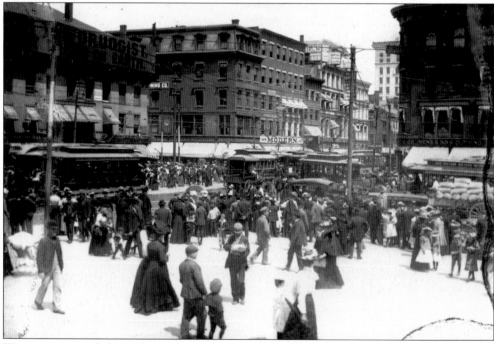

Worcester entered the 20th century as a prosperous and vibrant city with a diverse industrial base that enhanced its economic viability. Nowhere was the pulse of the city more rapid than at Harrington Corner. Main, Pleasant, and Front Streets converged here, in the heart of the retail district. As is evident in this photograph, residents competed with the streetcars and delivery wagons for control of the streets.

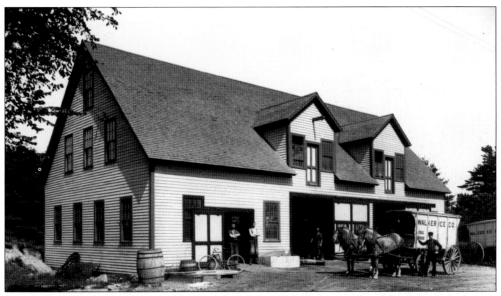

A teamster, mechanic, and two blacksmiths of the Walker Ice Company strike a pose, in this interesting photograph taken at the company's Lakeside barn *c.* 1908. Established as Walker and Sweetser *c.* 1859, the company was primarily an ice supplier in its early years and branched out into the coal and wood business prior to its closure in the 1950s. The company survived numerous fires, including infernos in 1928 and 1935 that destroyed icehouses at Coes Pond and Indian Lake, respectively.

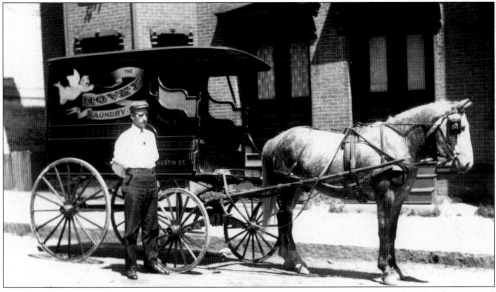

Henry Hovey, proprietor of the Hovey Laundry Company, stands next to his finely painted wagon in 1906. Hovey Laundry, which opened in 1906 at 41 Austin Street, had its beginnings as Hovey and Sons, at 2 Fruit Street, in 1901. The unusually low phone number (7) on the side of the wagon indicates that the company was among the very early subscribers. The Worcester Exchange, which operated as the New England Telephone and Telegraph Company, was organized in 1879. Records from May 13 of that year show a list of 91 subscribers. By 1898, that list had grown to 1,792.

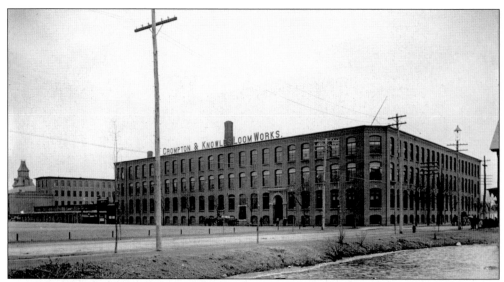

The 1897 merger between the Crompton Loom Works and Knowles Loom Works resulted in the formation of one of Worcester's largest businesses: Crompton and Knowles. By the 1950s, the company had more than 2,800 workers at its Worcester headquarters and was the world's largest manufacturer of textile looms, with plants in Belgium and the Netherlands. In 1970, its headquarters shifted to New York. Ten years later, the company closed its Worcester plant, bringing to an end 143 years of tradition in Worcester. The sprawling complex now lies vacant.

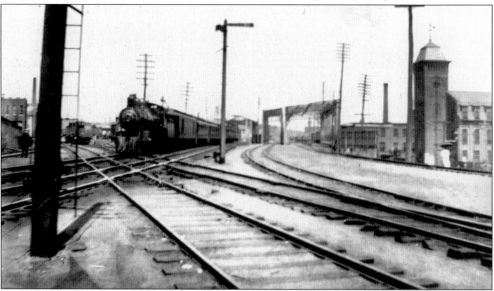

Railroads provided Worcester with the transportation facilities needed in the largest inland city in the United States not on a navigable waterway. This 1908 photograph offers a view of the major junction of the Norwich and Worcester, the Providence and Worcester, the Boston and Albany, and the New York, New Haven and Hartford. The mixed car in the left background is on the Norwich and Worcester tracks, while the Boston and Albany locomotive is pulling a seven-passenger train on the double tracks shared with the New York, New Haven and Hartford. The junction is raised above the intersection of Southbridge Street and Quinsigamond Avenue. Beneath the signal bridge in the distance, the city hall tower can be seen.

This *c.* 1910 view shows the former schoolhouses at Dix Street. School No. 1 (center), occupied in 1868, stood alone until the opening of School No. 2 in 1902 (far right). On January 12, 1968, a fire very quickly destroyed the older schoolhouse. Luckily, the fire began when most students were home at lunch. School No. 2 continued to operate until 1971.

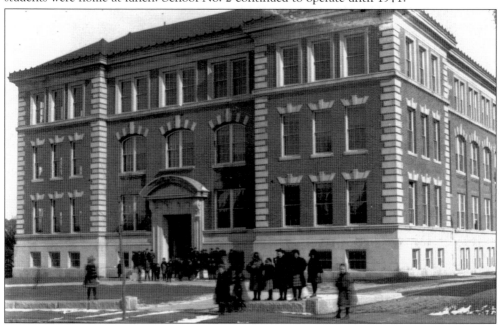

Schoolchildren gather in front of South High School *c.* 1902. As Worcester's high-school population began to swell, the need for a new school became acute. South became the first high school located outside of downtown and the largest constructed by the city up to that point, at a cost of $180,000. The building, designed by the Worcester firm of Frost, Briggs and Chamberlain, opened on Richards Street in September 1901. Currently, the building houses the Goddard School of Science and Technology.

This building at the corner of Woodland and May Streets was once home to a day and boarding school begun by Ellen Kimball in 1891. According to an early advertisement in the *Worcester City Directory*, this boarding school offered college preparatory courses and instruction in "music, art, languages, physical and voice culture." Kimball ran the institution until her death in November 1912. The building has been used for years as an apartment house.

Park Avenue, or "the Boulevard," was constructed as a circumferential road around the central city. Levi Lincoln, mayor when Worcester became a city in 1848, envisioned in 1870 a broad thoroughfare around the outskirts of the city. Although Mayor Clark Jillson vetoed the plan, the city council overrode the veto. Completed in 1877, Park Avenue today is the city's principal commercial street. Three-deckers dominate this 1901 streetscape opposite Charlotte Street. The Park Avenue Market is located in the three-decker in the center with the buggy in front of it.

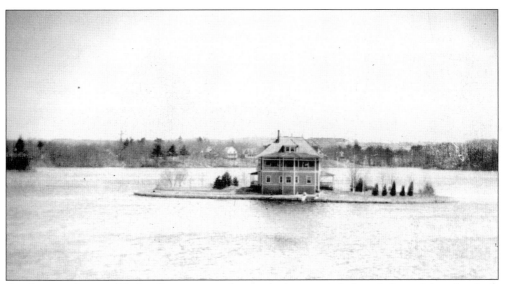

As the popularity of Lake Quinsigamond increased, many of the city's social and ethnic organizations established summer clubhouses along the shore and on the numerous islands. At various times, the Frontenac and Rostrevors Clubs met at this scenic spot on Sugarloaf Island. Both groups were organized by the city's French residents.

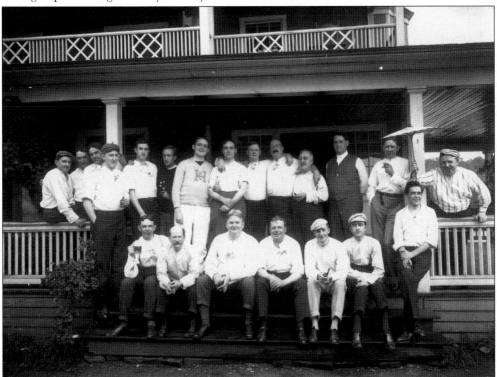

This gathering at the French social fraternity known as the Frontenac Club was held on the shore of Lake Quinsigamond. The club was formed in 1897, and a clubhouse was built that year under the direction of Joseph Godfroi Vandreuil, a Worcester general contractor who later became president of the club. Note the young man wearing the Holy Cross sweater.

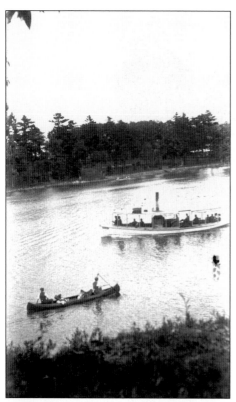

Steamboats and canoes plied the waters of Lake Quinsigamond during the lake's heyday as the area's premier summer recreational destination. Various steamboat companies offered tours and excursions along the lake, and for a moderate fee, a steamer could be rented for private parties and outings. Canoe and boat rentals were readily available as well.

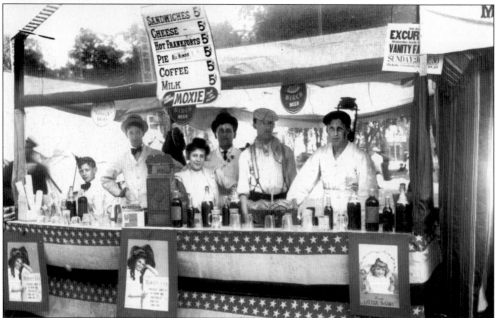

Employees of the George F. Hewett Company are shown manning a booth at an unidentified festival in Worcester c. 1900. The G.F. Hewett Company was a wholesale liquor distributor and soda manufacturer on Waldo Street. Among the better known products of this concern was Cold Blast ginger ale.

In 1901, the Worcester Slipper Company, established in 1899 by J. Prescott Grosvner, moved into this factory at 370 Park Avenue. The company manufactured slippers, auto and carriage boots, and Grosvner's Firfelt footwear. In 1915, the Daniel Green Felt Shoe Company bought the concern and continued to manufacture footwear at this location for several years. Later the home of the Coppus Engineering Company, the building was demolished in the early 1980s.

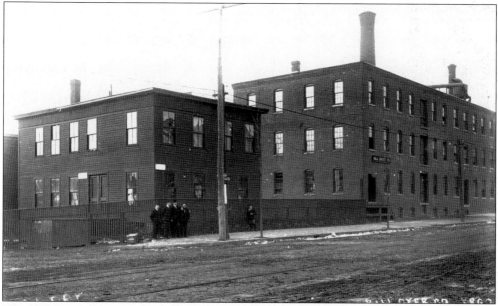

The Hill Dryer Company had this factory complex constructed at 340–350 Park Avenue in 1890. Established in 1876 by Joseph P. Hill, the concern manufactured such products as ash sifters used in emptying the furnace and balcony clotheslines for the hundreds of three-deckers that were then being constructed throughout the city. Although the company eventually moved from this location, it remained in business until the 1950s as a division of the Moulton Ladder Manufacturing Company.

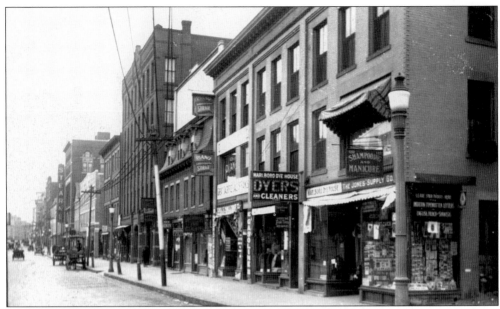

This early-1900s photograph shows a unique street scene from the courthouse end of Main Street looking back toward city hall. Still in use, the five-story Armsby Building (center), located at 144–148 Main Street, was constructed in 1885 at a cost of $30,000. The oldest remaining commercial block downtown is the four-story Elwood Adams building (left of the Armsby), built in 1831.

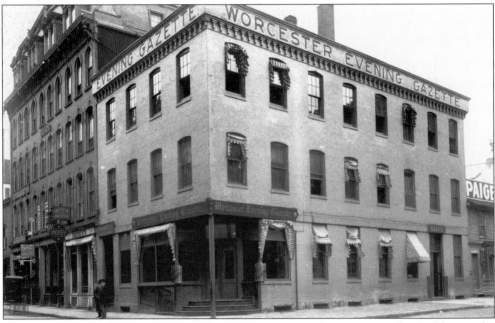

Shown c. 1908, the *Worcester Evening Gazette* moved its headquarters into this building at the corner of Mechanic and Norwich Streets in 1902. The *Daily Morning Transcript* began on April 1, 1851. In 1866, it became the *Worcester Evening Gazette*, which consolidated with the *Worcester Telegram* in 1920 and relocated to the *Telegram* headquarters on Franklin Street. The papers are now published under the banner *Telegram and Gazette*.

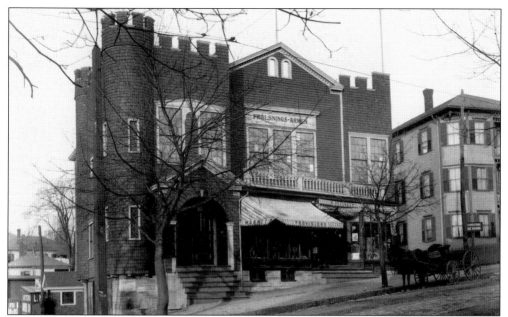

Worcester No. 3 Corps of the Salvation Army, established in 1893 and identified in Swedish above the awning (Frälsnings-Armén), was one of three Swedish-speaking corps organized to serve the Scandinavian residents of Worcester. Shown *c.* 1908 is the unique headquarters, located at 135 Belmont Street on the corner of Oakwood Place. The corps also maintained a large summer tabernacle at the intersection of Olga Avenue and Vinson Street.

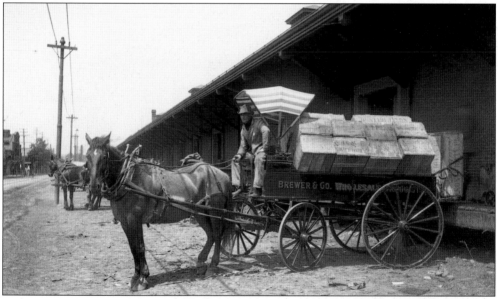

Between Franklin Street and Union Station was, until several years ago, the long railroad freight house. At that time, nearly all freight goods were delivered by rail. In this photograph, the delivery wagon of Brewer and Company Druggists is backed up to the platform with a load of merchandise that is apparently from India. Goods were off-loaded from the freight cars behind the building and were sorted and stored in the freight house to be picked up by the consignee.

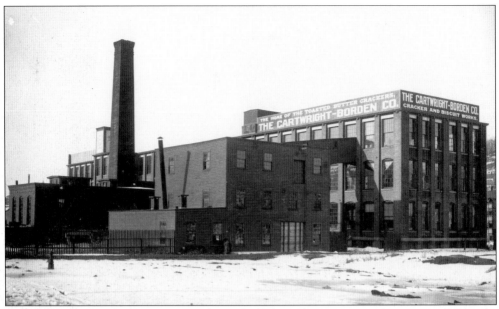

The Cartwright-Borden Company was located off Shrewsbury Street at the corner of Nebraska and Winona Streets. Fred H. Cartwright and Clinton A. Borden, partners in this concern, were originally associated with the C-D-B Biscuit Company. In 1901, they established this business, which manufactured crackers and biscuits. The business was later organized under the name New England Biscuit Company.

The Gage Street School is shown c. 1902. Occupied in 1885, the building was enlarged in 1899 and 1924. A fire caused massive damage c. 1959, and the school underwent a partial demolition and reconstruction. After its closing as a public school in June 1991, the building was renovated and reopened as the Seven Hills Charter School.

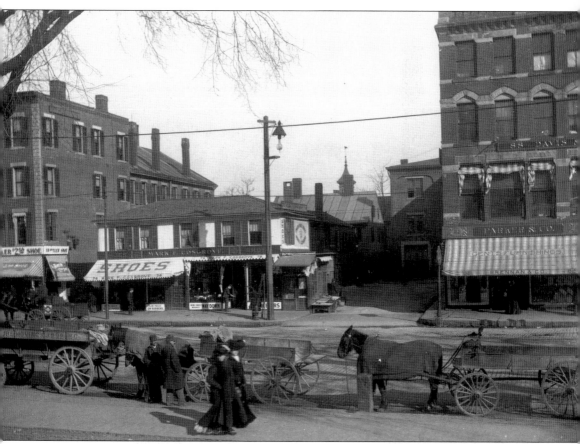

This 1904 photograph shows a line of delivery and moving wagons across the street from 78–82 Front Street. In the four-story building at 82 Front Street is the Parker and Company sign, above the awning advertising gents' furnishings. The clothing business was started in 1894 by William P. Brennan and changed to Parker in 1902. The M.F. Cosgrove shoe store, at 78 Front Street, was started in 1893 by Mark F. Cosgrove and, in 1913, moved from Front Street to 550 Main Street.

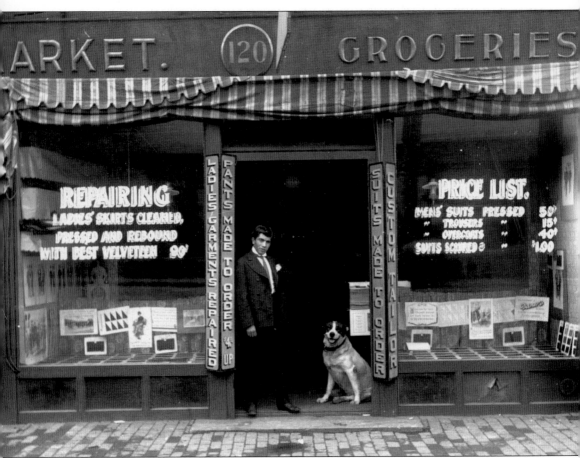

Garabed Zakarian, a member of the city's large Armenian community, operated a tailor shop at 120 Southbridge Street in the early 20th century. Pictured *c.* 1904 is most surely his son Charles and what looks like the shop mascot. Zakarian's establishment was located next to the grocery business of J.J. English.

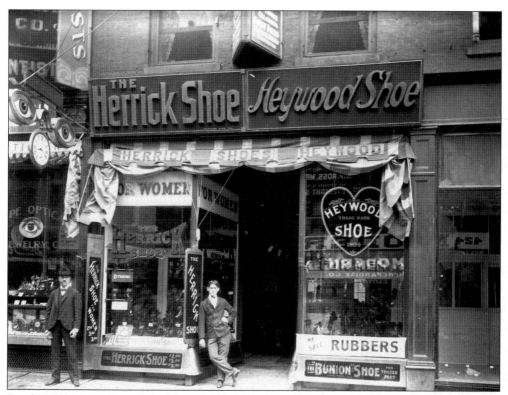

Employees pose in front of the Herrick Shoe Store *c.* 1909. Herrick and Heywood–brand shoes are prominently displayed in the windows of the business, which was located at 415 Main Street. The Heywood Boot and Shoe Company, located at 70–72 Winter Street, began *c.* 1858.

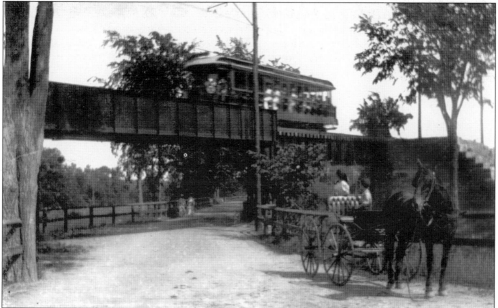

These two young men have stopped their buggy to watch the trolley car of the Worcester and Southbridge Railway cross the dry bridge in the Jamesville section of Worcester.

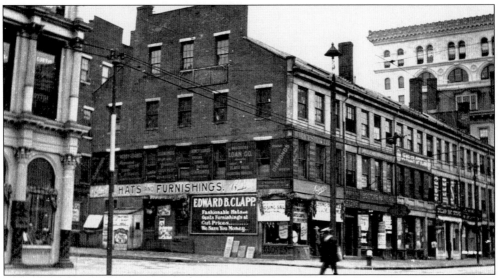

This 1904 photograph shows the first granite mercantile block in the city: the Butman Block, located on Main Street between Elm and Pearl Streets. The block was designed by Lewis Bigelow for Benjamin Butman and was constructed, together with the adjacent Brinley Block, in 1835–1837. The *Worcester Telegram* had its beginning in the Butman Block. Notice the State Mutual building in the background. The Butman Block, one of the last of the early commercial buildings that lined Main Street, was taken down in 1906. Today, the site is occupied by the Slater Building.

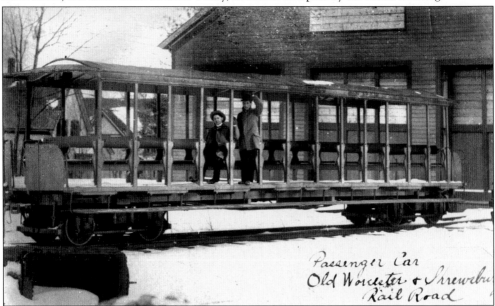

In 1897, the Worcester Consolidated Street Railway leased the Worcester and Shrewsbury Railroad, or as it was affectionately known, "the dummy line." This narrow-gauge line ran from near Union Station to its terminus at Lake View on Lake Quinsigamond. A small dummy engine pulled the cars for the refreshing two-mile ride to the lake in the summer. After leasing the line, a parallel electric trolley line was built, putting the little dummy engines into retirement. This photograph, taken on a cold winter day, shows an open double-truck 14-seat nonelectric car. The last car operated on this line *c.* 1934.

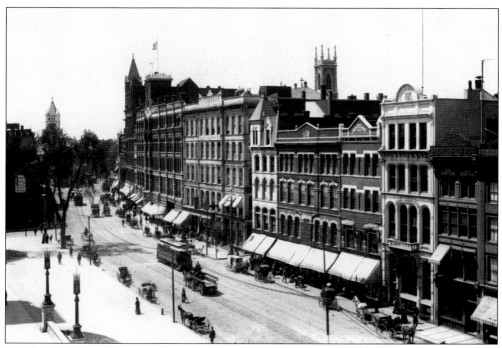

The heart of the commercial district is seen in this 1900 view of Main Street at city hall. The awnings of the John C. MacInnes Department Store (foreground) and the Denholm and McKay Boston Store (background) shade shoppers from the summer sun. Streetcars and wagons traverse the city streets, while in the distance looms the tower of the U.S. post office at Franklin (later Federal) Square.

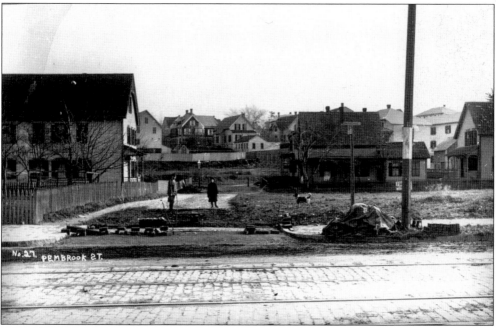

Bystanders inspect the paving of Pembroke Street at Park Avenue *c.* 1906. The street is being lined with cobblestones. Pembroke Street first appeared in street listings *c.* 1881.

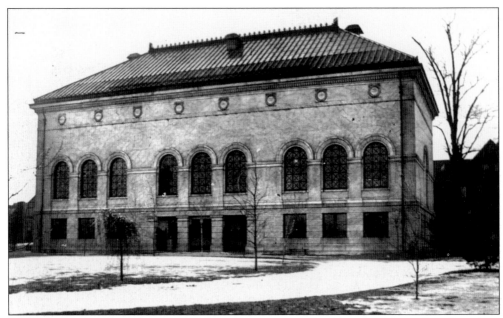

On June 24, 1897, the cornerstone for the Worcester Art Museum was put in place. Less than a year later, on May 10, 1898, the museum was opened to the public. Designed by prominent Worcester architect Stephen C. Earle and built by E.J. Cross, the building looks considerably different today from the way it appears in this 1900 photograph due to many additions. In 1997, renovations began that included the main staircase.

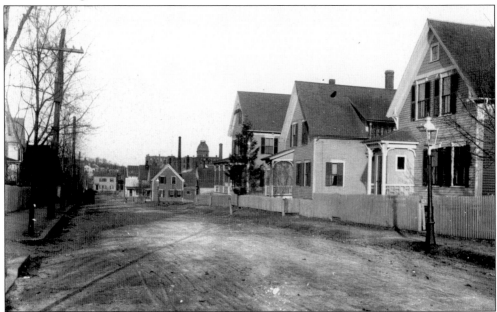

Residences line Winfield Street, in this view looking north to Chandler Street in the 1890s. In the distance stands the Harrington and Richardson Arms Company, at the intersection of Chandler Street and Park Avenue. Winfield Street was named after Worcester native Brig. Gen. Winfield Scott, military hero of the War of 1812 and the Mexican War. Scott ran for president under the Whig banner but was defeated by Franklin Pierce in the 1852 election.

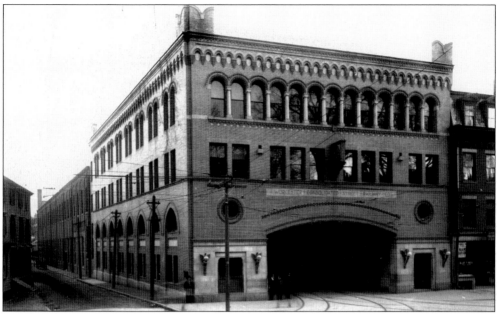

Constructed in stages between 1893 and 1907, the Market Street carhouse of the Worcester Consolidated Street Railway Company housed numerous offices, in addition to the system's chief repair facilities. The building contained an elevator capable of lifting trolleys to and from the second-floor repair area. Despite talk of preserving the structure, it was demolished in the 1980s to make room for the Marriott Hotel at Lincoln Square. Located next door was the Lincoln Square Pool Room, owned by Olof T. Ries.

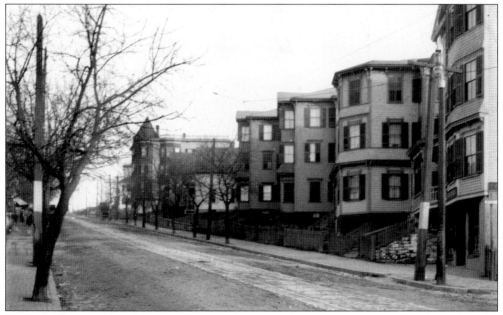

Finlandia Grocery Union, one of Worcester's cooperative movement stores, was located in the lower level of this three-decker (right) at the corner of Elizabeth Street. The cooperative stores were founded by the Scandinavian immigrants who lived in most of the three-deckers seen marching up Belmont Hill in this Nordic enclave.

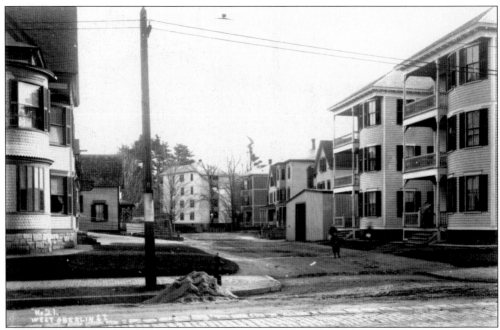

West Oberlin Street first appeared in city directories in 1888. By the time this photograph was taken *c.* 1906, several three-deckers had been constructed. In the foreground is Park Avenue, complete with trolley lines.

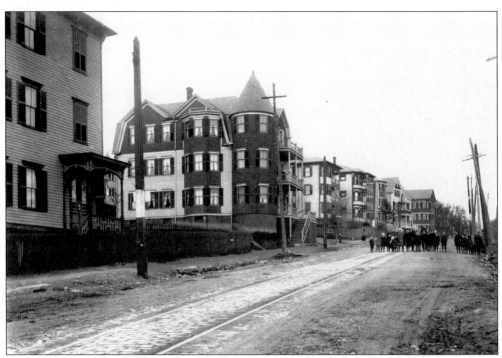

This view shows Belmont Street *c.* 1900. The photographer captured an expectant group of children in an otherwise empty street atop Belmont Hill. The stylish towered and gabled three-decker was just one of many styles of three-decker housing available to Worcester contractors.

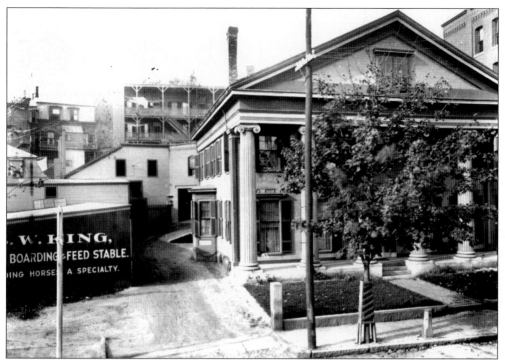

This early-20th-century photograph of the home and livery stable of Charles W. King, at 13 Piedmont Street, shows the elegance of a former time. King operated a stable for boarding horses next to his home from 1885 until 1908. He is listed as operating a public ambulance in 1897 and 1898.

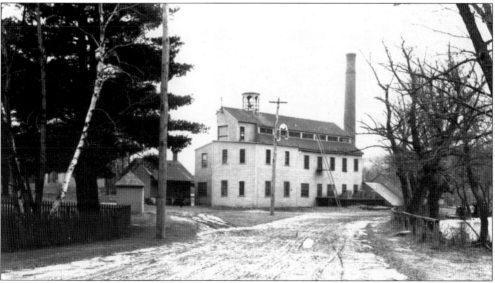

In the late 1870s, Frank C. Smith began operations in his woolen mill, on Mill Street in Tatnuck. The mill produced satinet, a silk-like fabric used in the manufacture of pillowcases and sheets. This *c.* 1900 photograph was taken from the intersection of Chandler and Mill Streets. Today, the mill site houses the Tatnuck Arms apartments, and the site across the street is occupied by a McDonald's restaurant.

A small example of Worcester's diverse manufacturing base can be seen in this page of advertisements from the 1908 *Worcester City Directory*.

Four
1910–1920

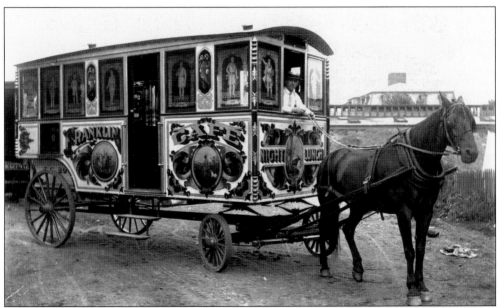

This 1910 photograph shows an early Franklin lunchwagon that was produced by John J.E. Hennigan, whose business began at 22 Cutler Street in 1908 and moved to 38 Cutler in 1912. With the increasing popularity of motor vehicles and improved public transportation, Hennigan closed his business in 1917.

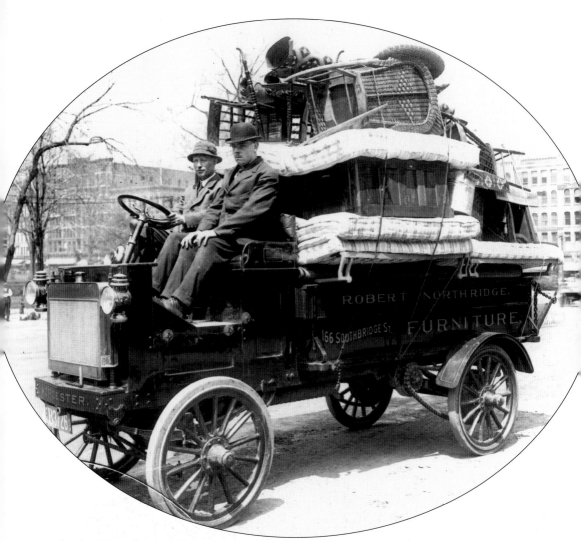

As this 1913 photograph clearly shows, the Robert Northridge Furniture Company certainly made use of its delivery vehicles. With the common in the background, employees of this home furnishings establishment pose with a fully loaded Sanford truck at Salem Square. Established in 1889, the business was once the city's oldest and largest furniture store. Notice the chain drive to the rear wheels.

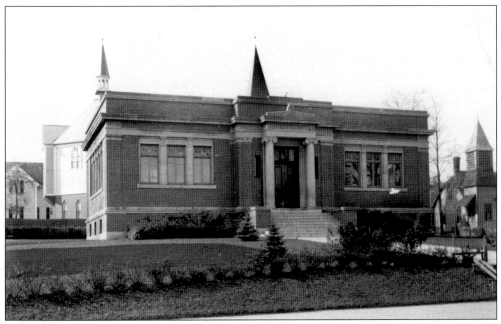

The Quinsigamond Branch Library, designed by the local firm of Fuller and Delano, was constructed at the corner of Millbury and Stebbins Street. American Steel and Wire, the neighborhood's dominant employer, donated the land for its construction. To the rear of the library, seen here shortly after its 1914 opening, stands the First Swedish Methodist Church. To the right is the Quinsigamond Baptist Church. The library was spared total demolition and was incorporated into the construction and renovation of the current Quinsigamond School.

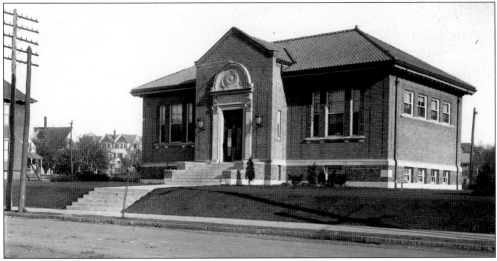

Andrew Carnegie's benevolence benefited Worcester in the form of three branch libraries, the result of a $75,000 gift to the city. In February 1914, the libraries opened to the public. Shown here shortly after its opening is the Greendale Branch Library, now known as the Frances Perkins Library. Several Greendale manufacturers—among them the Norton Company, the Osgood-Bradley Car Company, and Worcester Pressed Steel—donated the land upon which the building sits. Lucius Briggs, a prominent city architect, designed the original structure, which was enlarged in 1996.

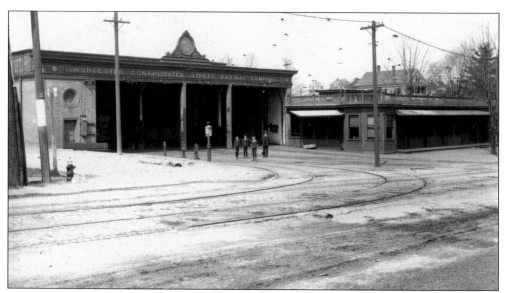

The extensive operations of the Worcester Consolidated Street Railway necessitated the construction of carhouses throughout the county. In this view, children pose with an employee in front of the Gates Lane Carhouse, at the intersection of Main Street and Gates Lane. Erected in 1901 and enlarged in 1912, the terminal could provide service for many streetcars.

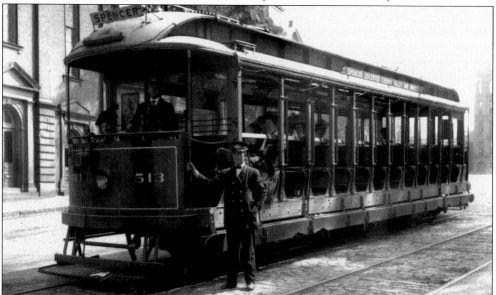

Employees of the Worcester Consolidated Street Railway pose with car No. 513 at Salem Square c. 1910. With passengers aboard, the car seems ready to depart for its trip to Spencer. To the left stand two of the city's numerous ethnic churches, the Salem Square Congregational (Swedish) and Notre Dame des Canadians (French). The railway came into being after a series of mergers and consolidations of the various regional streetcar firms. The first quarter of the 20th century proved to be the golden era for the company. It was reported that at year's end in 1916, some 72.7 million passengers had been serviced by a fleet of 429 cars on 300 miles of track. The popularity of the automobile and increased operating costs resulted in the company going into receivership by the early 1930s. The last day of streetcar service was December 31, 1945.

In the center of this 1916 photograph is the Royal Theater, one of several theaters operating at that time, located at 623 Main Street. To the right is the Worcester Market, with a sign in the window advertising haddock for 4¢ a pound. It appears from all the loose cobblestones in the street that some repair work was being done.

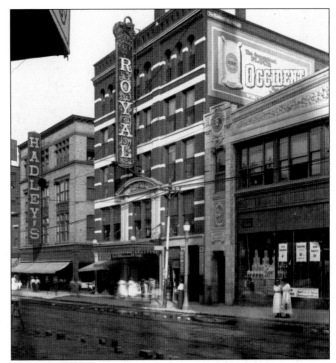

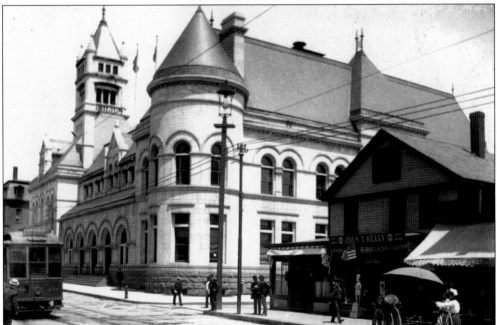

The post office building, with its imposing tower and turrets, dominates the scene at the intersection of Main and Myrtle Streets. In this c. 1912 view looking toward city hall, are John T. Kelley's tobacco store, at 603 Main Street, and the Pellettiere family fruit business next door. This scene has changed considerably. The post office was demolished and replaced in the 1930s. The Registry of Motor Vehicles now occupies the former Kelley-Pellettiere site. Myrtle Street has been widened.

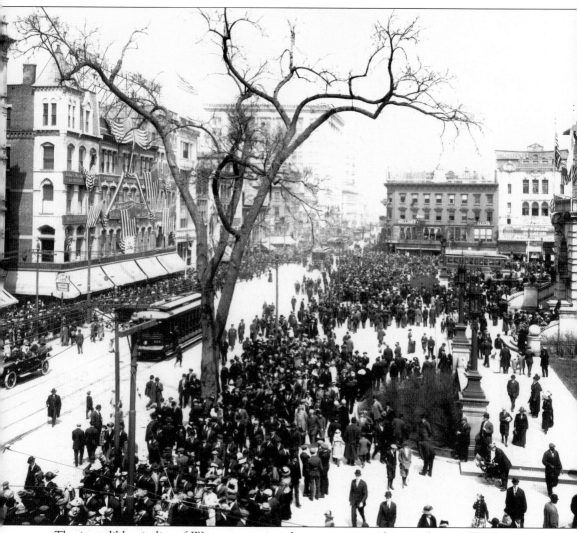

The incredible vitality of Worcester as an urban center is evident in this *c.* 1915 downtown scene. As is clearly shown, crowds inundated Main Street and patronized the dozens of establishments that made up the city's foremost shopping district along Main and Front Streets. The city hall area was alive with activity, as people waited for the numerous trolleys of the Worcester Consolidated Street Railway or gathered to chat with family and friends, all the while absorbing the heady surroundings of what was once one of New England's most vibrant cities.

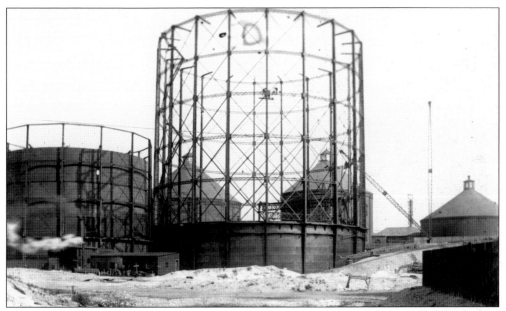

The gas holding tanks of the Worcester Gas Light Company are shown in this 1915 view. Established in 1852, the company built its first holding facility on Quinsigamond Avenue. The introduction of natural gas, delivered by pipeline from the fields, made these tanks obsolete, and they were torn down.

Motorcycles were a popular means of transportation in early-20th-century Worcester, especially among the young people. Shown are proud driver Otto J. Hultgren and his brother Oscar on his Indian motorcycle in Quinsigamond Village. Their father, Lars, began one of Worcester's many tool and die shops, the Hultgren Manufacturing Company, located on Whipple Street.

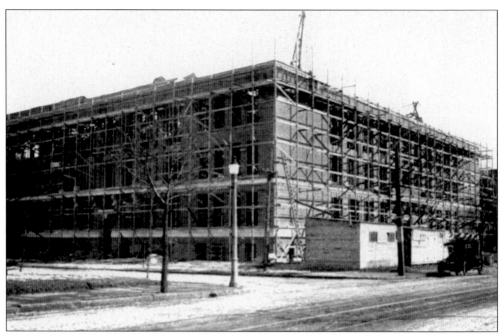

Scaffolding surrounds the unfinished addition to the North High School, in this 1915 photograph. The high school opened in a former grammar school on Salisbury Street in 1911. Soon thereafter, rising enrollments forced the erection of this large addition, which increased the size of the school fourfold. After North High School relocated in 1980, the building was transformed into an apartment complex.

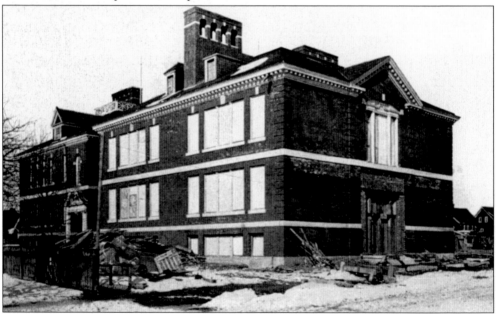

The Midland Street Schoolhouse addition nears completion, in this 1915 photograph. Occupied in April 1897, the elementary school warranted expansion due to the rapid growth of the Newton Square area. The addition tripled the student capacity of the building, which still serves the surrounding neighborhood.

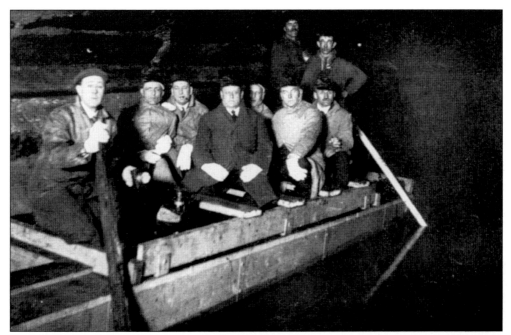

Deep under the streets of Worcester, a newly constructed sewer is inspected by the Worcester Committee on Sewers in 1915. Increased development put pressure on many municipal departments as the demand for services increased; the sewer department was no exception. In 1915, there were still Worcester neighborhoods unconnected to the municipal sewerage system.

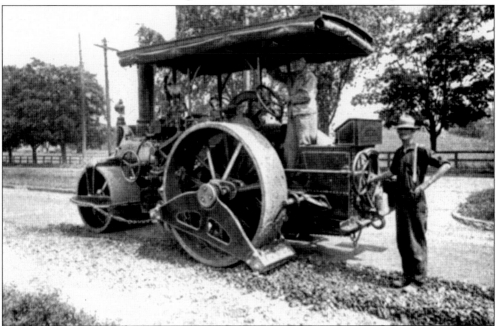

In 1915, the city purchased this combination roller and scarifier to help in street maintenance. Albert T. Rhodes, the commissioner of streets, praised the efficiency of the new machine "as but few men are needed with it." The city's street department was no different than any other; it had to deal with increasing burdens, the result of a prosperous and expanding city.

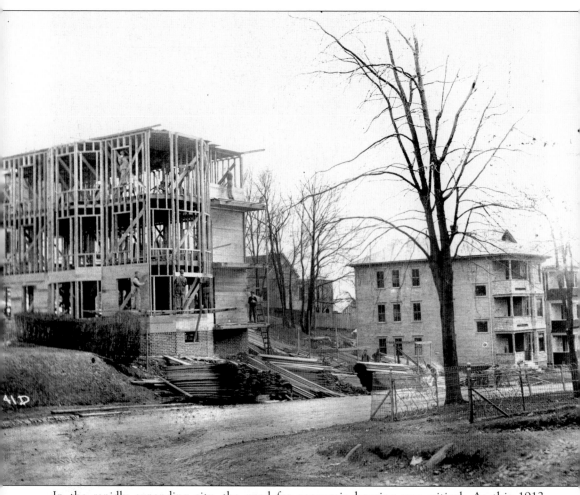

In the rapidly expanding city, the need for economic housing was critical. As this 1912 photograph shows, Worcester's solution was the three-decker. In one 10-year span, more than 2,000 were built. Rare, indeed, is a photograph showing a three-decker under construction. Material for these three-deckers was shipped by rail similar to a kit house. Thirty-foot joists extended from sill to plate in these balloon-framed structures. This Moon and Company photograph shows workmen erecting a three-decker on Belmont Hill.

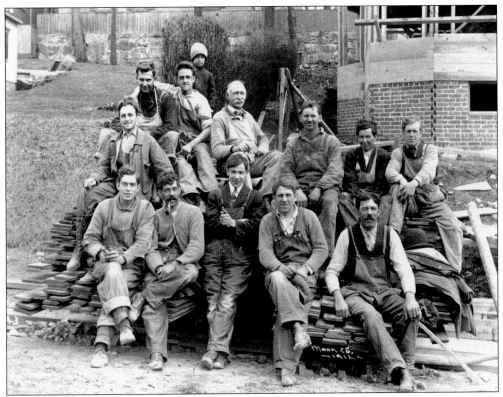

Members of the construction crew of the three-decker shown in the previous photograph take a break. Identified are Neal S. Moreau (back row, second from left) and his brother Frank Moreau (second row, far left).

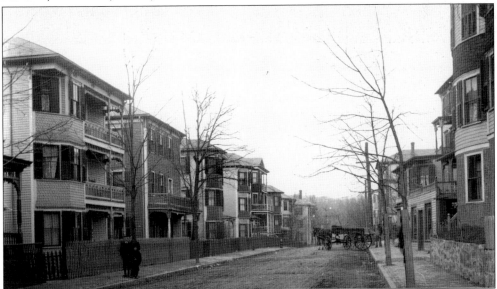

Shown c. 1910 is a typical Worcester street lined with three-deckers. In the distance, the Johnson and Ketteli Wholesale Grocers Company delivery wagon is being unloaded in front of a neighborhood store.

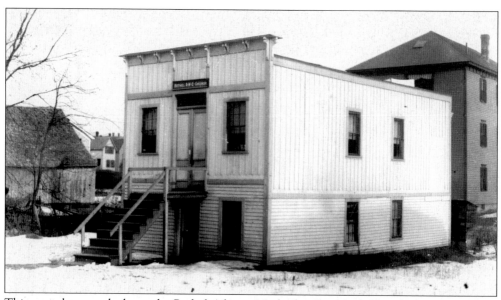

This rare photograph shows the Bethel African Methodist Episcopal Church on Parker Street c. 1913. Organized in 1867, this congregation later worshiped at Hanover and Laurel Streets and then at 302 Main Street. One of five black churches in the city, it was destroyed by fire in 1926.

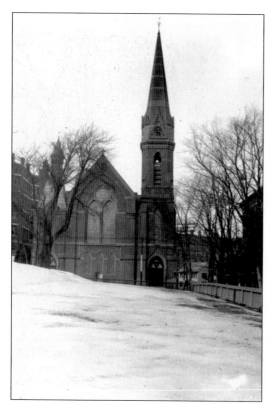

Trinity Church, at Main and Chandler Streets, is shown c. 1915. The congregation organized in 1830 and built this house of worship somewhat later. Not immune to public betterment, the church was torn down for the widening of Chandler Street in 1929.

The Harrington Richardson Arms Company, like many other companies, sponsored numerous activities within the Worcester community. This c. 1920 photograph shows a baseball team posing in clean uniforms, leading one to believe that the picture was taken before the game was played. Notice the separate fingers of the early baseball gloves.

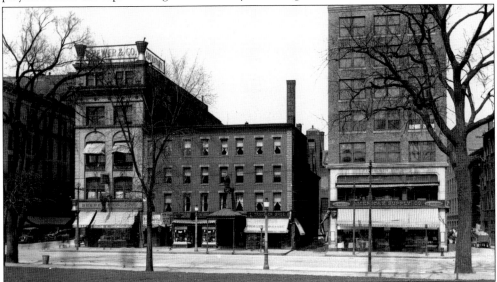

The Front Street Block, between Commercial and Mercantile Streets, is pictured in this 1914 view. Two of the city's most prominent businesses were located here. The Brewer Building, (left) was home to Brewer and Company, wholesale and retail druggists. American Supply (right), retailer of furniture and household goods, was located at the corner of Front and Mercantile Streets in the Ellsworth Building. This entire block was demolished in the late 1960s to make way for the Worcester Center Galleria.

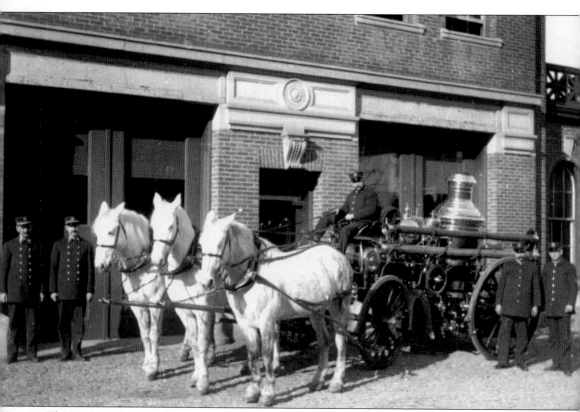

The Eastern Avenue Fire Station is shown with a team of horses hooked up and ready to respond to a fire call. This *c.* 1911 photograph was taken at the height of fire horse ownership in the city, with 87 horses in the fire department. By 1926, that number was down to one, with the last horse retiring in 1932.

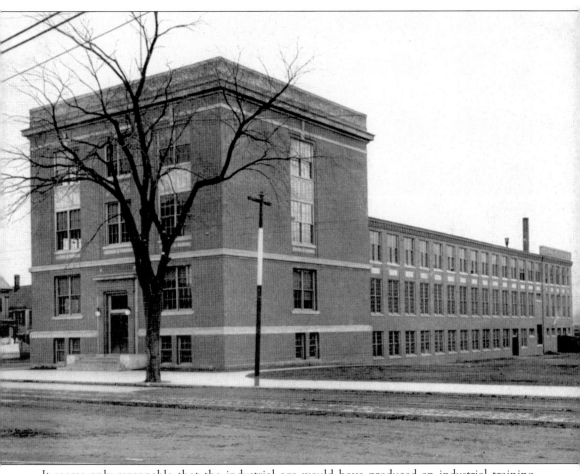

It seems only reasonable that the industrial age would have produced an industrial training school. After lengthy discussions, a committee was formed in 1907 to establish an industrial school in Worcester. The object of such a school was "to produce efficient, skilled mechanical workmen." Construction on the new school began in 1909 and progressed rapidly. On February 8, 1910, the Worcester Trade School was dedicated. Students still attend classes in this building after more than nine decades. The school has been enlarged over the years.

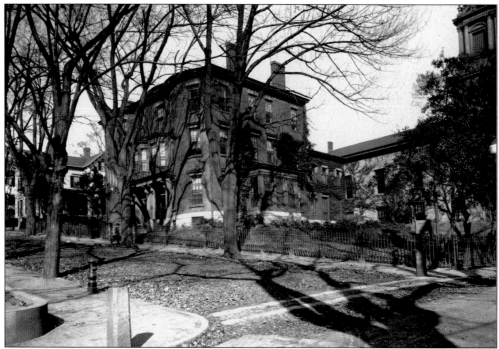

With the boys-only Worcester Trade School opening in 1910, it remained for girls to have their own trade school. This c. 1913 photograph shows the original girls' trade school, which opened to 75 girls on September 20, 1911. The school was located in a three-story building at the corner of State and Main Streets, next to the Unitarian church.

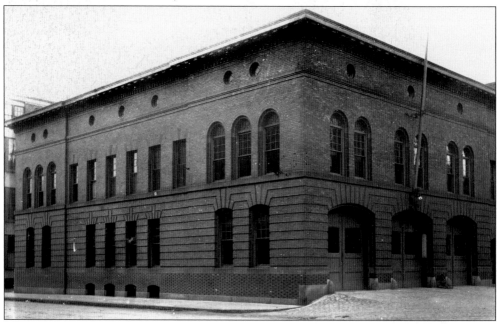

The School Street Fire Station, shown in this 1910 photograph, was built in 1906. It housed Engines No. 3 and No. 16 when it was torn down in 1974 to make room for New England Telephone Company construction.

118

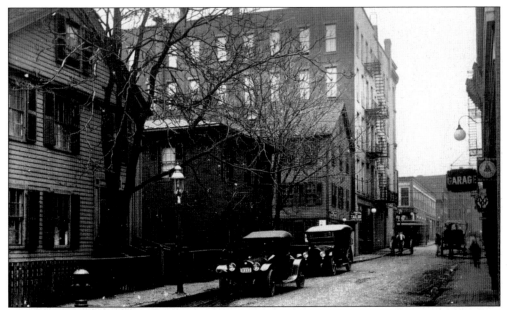

Warren Street is shown in a 1916 view looking toward Front Street. To the right is the Warren Garage, and across the street stands Louis Porter's tailor shop. Automobiles are parked outside two private residences, and the rear of the Warren Hotel, at 201 Front Street, completes this view. By 1971, this entire neighborhood had been demolished to make way for the Worcester Center Galleria complex.

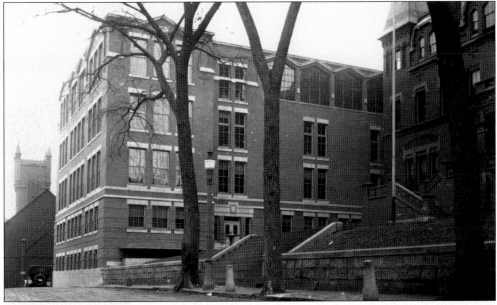

In June 1914, the Classical High School was transferred from Walnut Street to the former English High School building at Chatham and Irving Streets. That September, the city's newest high school, Commerce, opened in the Walnut Street building. To accommodate the increase in students, a large addition was constructed, consisting of classrooms, a gymnasium, and an assembly hall. Shown here is the Commerce High School addition shortly after its completion. To the right is the original school, which opened in 1871.

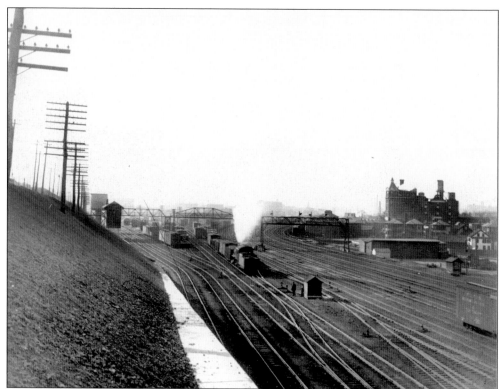

Worcester's railroad facilities developed rapidly after the Civil War. This availability is perhaps the major reason for the enormous development of the ceramic, steel, and tool industries in the city. Without the extensive railroad facilities, the shipping of manufactured goods would have been hampered greatly. This December 1913 photograph of a railroad yard, with its multiple tracks entering Worcester, shows the intense development of the shipping and transportation facilities.

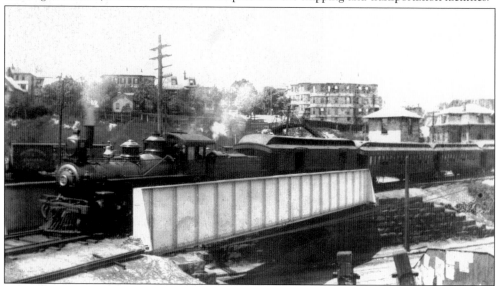

A Boston and Albany locomotive hauling a mixed train crosses Southbridge Street as it heads toward the new Union Station, in this 1911 photograph.

120

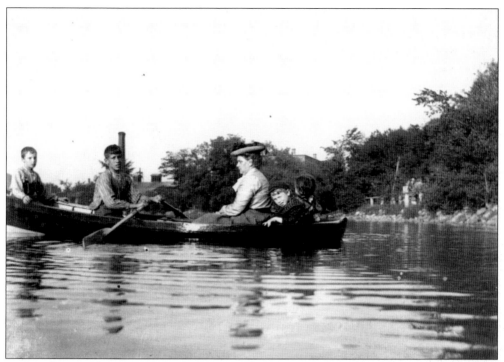

In this photograph taken *c.* 1910 on a warm summer's day, a family enjoys a leisurely row on Coes Pond. One wonders if the father was the photographer. The smokestack of the Coes Knife Company's factory on Mill Street rises in the background.

This *c.* 1914 storefront photograph shows the Williams stationery and book business, with a large display advertising the Parker fountain pen. Interestingly, in the background inside the window can be seen strips of Worcester postcards for sale, many of which (such as those showing Union Station, city hall, and the Masonic Temple) can be recognized with a magnifying glass.

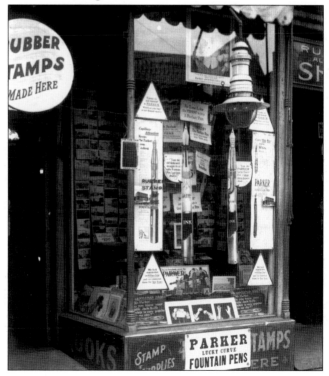

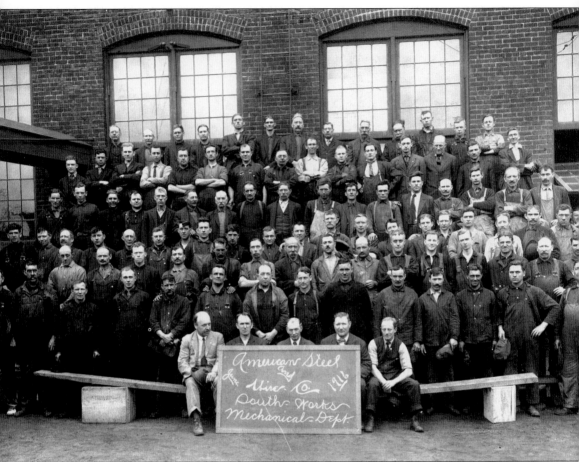

The Washburn and Moen plant, on Grove Street, had been in operation for 15 years when the company's second factory, the Southworks at Quinsigamond Village, was opened in 1846. By 1916, the company had helped form American Steel and Wire, which became a subsidiary of U.S. Steel. The plant in Worcester became the largest factory of its kind in the nation. The Southworks was responsible for the growth of Quinsigamond Village, employing Irish and then Swedish workers, who flocked to the mills by the thousands. In this 1916 photograph of the Southworks Mechanical Department, employee Michael James McCarthy stands in the fourth row, seventh from the left.

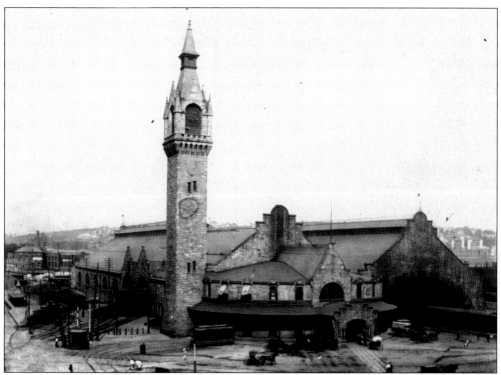

This is an excellent photograph of the 1875 Union Station at Washington Square. The massive granite station and terminal train shed created an impressive sight for the many people arriving in the city. A new station opened in 1911, but the old landmark tower remained until 1959.

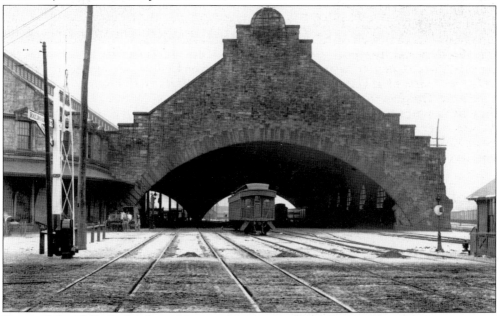

Designed by H.H. Richardson, Union station opened on August 15, 1875. Its cavernous passenger shed is clearly shown in this 1902 photograph. The stone lions at the base of the arch are now located at the entrance to East Park.

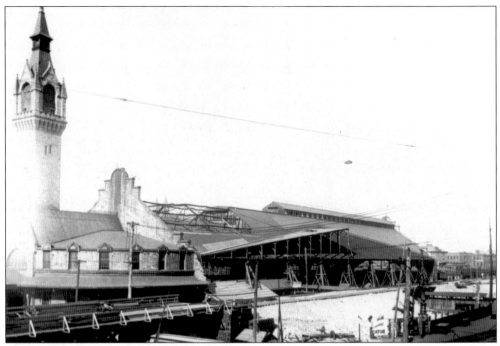

The year 1910 saw the partial demolition of the old Union Station. Within a year of this photograph, the adjacent new station opened, replacing this passenger depot. Here, the demolition is in progress while the elevated approaches to the new station are being built. The waiting room of the old station, which remained, and was used by the railroad as a repair shop. The 1875 tower stood until 1959, when it was torn down to make room for the in-town expressway, Interstate 290.

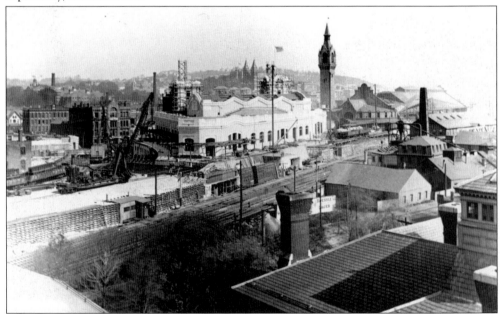

Scaffolding surrounds the still unfinished towers of the new Union Station. The elevated tracks and new bridges approaching the station are being erected, in this 1910 picture.

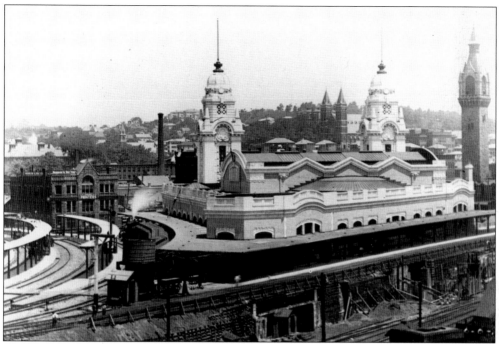

The new Union Station, erected by the Boston and Albany Railroad at a cost of over $1 million, was opened for traffic on June 4, 1911. Here, we see the old station, with its tall tower, in back of the new station. The three-year process of raising the tracks approaching the new station eliminated all the dangerous grade crossings, which was a boon to city traffic.

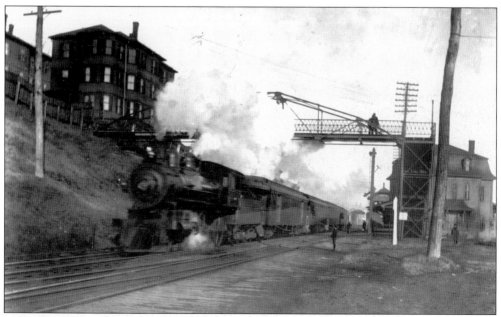

The billowing smoke and steam from a New York, Hew Haven and Hartford locomotive are captured in this dramatic photograph, as the train idles beneath the pedestrian bridge off Canterbury Street.

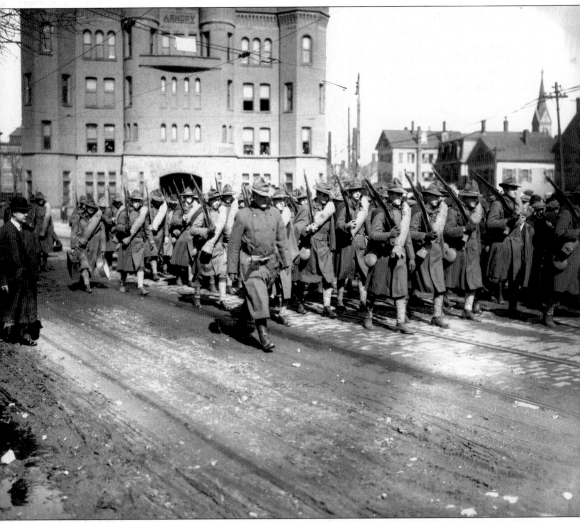

This company of soldiers in full gear is seen leaving the armory in preparation for service in World War I. The armory was once the home of the Massachusetts National Guard. Recently, it was used by the Worcester Polytech Air Force ROTC for drill and ceremony. Currently, it is used as the Massachusetts National Guard Museum. After decades of use, the building was renovated in the 1990s.

In this 1917 photograph, soldiers are encamped at Green Hill Park, awaiting deployment for World War I. Mess tents are set up, and the cook prepares a meal outside of his tent.

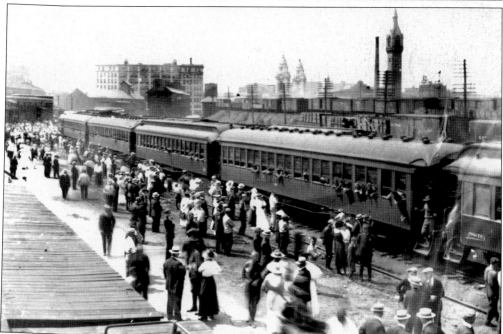

This World War I–era photograph of Washington Square symbolizes the human element, as relatives and friends gather to bid farewell to departing soldiers. The tower of the old Union Station (also called Union Depot) and the twin towers of its replacement loom in the background.

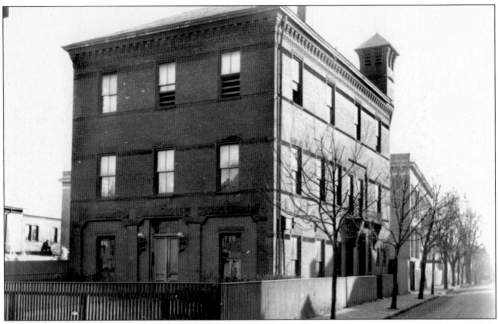

Pictured *c.* 1913 is the former Police Station No. 2, on Lamartine Street. Occupied in 1874, the building was enlarged with additional cell space in 1916. It eventually had its third floor removed and, after its closing, housed a variety of businesses, including Worcester Electrical Associates. The former Lamartine Street School No. 3 stands behind the station.

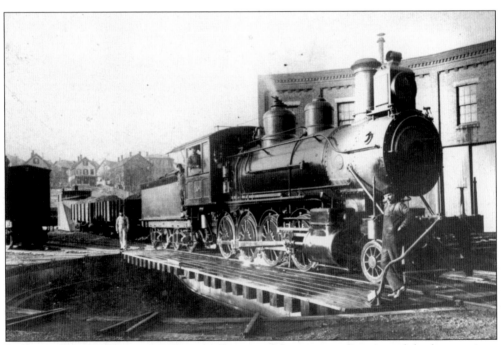

Just east of Union Station was this roundhouse, used to reverse direction of the locomotives. The houses of Providence Street can be seen in the background of this early-1900s photograph.